19th CENTURY MARITIME WATERCOLOURS

19th CENTURY MARITIME WATERCOLOURS

Adrian Vincent

DAVID & CHARLES

Newton Abbot London

For June

British Library Cataloguing in Publication Data

Vincent, Adrian
 19th-century maritime watercolours.
 1. Marine painting. British watercolours.
 History
 I. Title
 758'.2'0941

ISBN 0-7153-9278-6

Phototypeset by ABM Typographics Ltd, Hull
Printed in The Netherlands
by Royal Smeets Offset Weert
for David & Charles Publishers plc
Brunel House Newton Abbot Devon

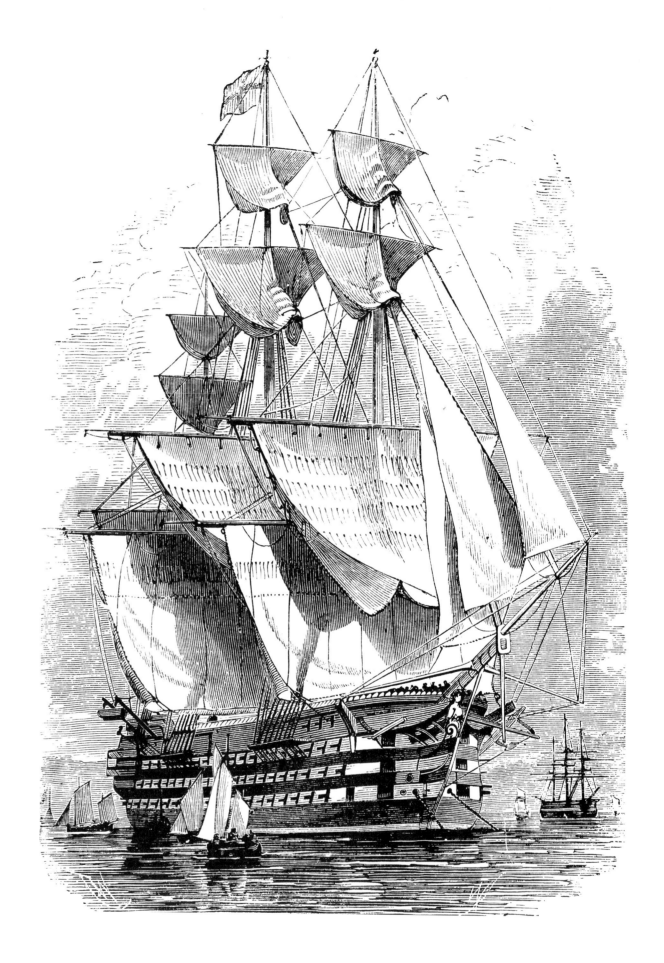

CONTENTS

ACKNOWLEDGEMENTS

The assistance of the following art dealers and auctioneers in lending colour photographs for this book is gratefully acknowledged.

Appleby's,
8 Ryder Street,
London SW1.

Bonhams (Auctioneers),
Montpelier Galleries,
Montpelier Street,
London SW7.

Bourne Gallery,
31 Lesbourne Road,
Reigate,
Surrey RH2 7JS.

British Museum,
London WC1B 3DG.

J. Collins & Son,
The Studio,
63 and 28 High Street,
Bideford,
Devon EX39 2AN.

Gebr. Douwes,
38 Duke Street,
St James's,
London SW1Y 6DF.

Fine Art Petworth plc,
Fernhurst,
Haslemere,
Surrey.

Fine-Lines (Fine Art),
The Old Rectory,
31 Sheep Street,
Shipston-on-Stour,
Warwicks CV36 4AE.

David James,
291 Brompton Road,
London SW3.

J. Morton Lee,
Cedar House,

Bacon Lane,
Hayling Island,
Hants PO11 0DN.

Manchester Fine Arts,
73-75 Princess Street,
Manchester M2 4EG.

Moss Galleries,
238 Brompton Road,
London SW3.

Phillips Fine Art Auctioneers,
Blenstock House,
7 Blenheim Street,
New Bond Street,
London W1Y 0AS.

The Priory Gallery,
The Priory,
Church Road,

Bishops Cleeve,
Nr Cheltenham,
Glos.

Royal Exchange Gallery,
14 Royal Exchange,
London EC3V 3LL.

Brian Sinfield,
The Granary,
Filkins,
Glos.

Sotheby's,
Summers Place,
Billingshurst,
Sussex RH14 9AD.

Spink & Son Ltd.,
5, 6 and 7 King Street,
St James's,
London SW1Y 6QS.

FOREWORD
John Worsley,
President, Royal Society of Marine Artists

It is not difficult for a present-day professional marine artist to appreciate and admire the extensive work and knowledge which has gone into producing this admirable volume by Adrian Vincent. His research of history and anecdote is prodigious and his knowledge of the subject impressive, and for a maritime painter like myself somewhat humbling.

One of the fundamental differences, seldom fully realised, between contemporary sea painting (or any modern painting for that matter) and that of the nineteenth century and times before, is that the camera as we know it had not yet arrived. Daguerre and others had, indeed, begun to explore the photographic process, but even by the end of the century the camera was still cumbersome, and exposures slow, so that it was not really a practical instrument for collecting the visual facts required for the study of the constant motion of sea and ships.

In the past there was no way of making a visual representation other than through the eye and hand of a skilled artist. When Henry VIII wished to know what Anne of Cleves looked like before committing himself to marriage, he had to send Holbein to paint her portrait — her minions could not simply send him a happy snap (the artist flattered her too!) — and the same applied to the recording of ships and the sea up until fairly modern times. So this book is a wonderful window onto the maritime life of the era.

The dawn of the steam ship took place during the century, but sail remained the prevailing source of power for ships, and accuracy was vital in depicting them convincingly. Ship painting, in my opinion, is more difficult than the art of painting human portraits (and I do both): more knowledge of the subject is required because the artist's work will be open to view and criticism from so many people who are familiar with the intricate details.

For example, ship's gear — whether ropes, deadeyes, blocks, canvas or masts — must be shown to be of the right thickness and strength for the work it has to do. One often sees paintings where masts are far too slender to survive the strain they would receive; likewise, shrouds and stays are sometimes painted as weak and thin, whereas halyards and sheets are actually more delicate. These matters, without being pedantic, are some of my own first yardsticks when judging a ship picture, and are of parallel importance to the emotional content, overall composition and subject.

The pictures in this book were painted long before the art world began to suffer from the 'Emperor's clothes syndrome' of modern 'contemporary' painting, whereby disregard for good drawing, colour and composition have somehow been woven into a kind of intellectual mystique, the bubble of which dealers and critics, with their apparent love of the obscure, dare not allow themselves to burst. In the painting of sea and ships there is no room for the 'happy accident' abstract.

The artists whose work is included on these pages were representational and proud of it, and those who see their pictures can delight in the realism and subject matter, the close observation that has gone into the work of painting sea, and the accuracy with which the ships are depicted.

Yet the wide assortment of shipping on the seas offered the nineteenth-century maritime artist a plentiful range of material to paint. Early in the century were fought Admiral Nelson's two illustrious sea battles, Copenhagen (1801) and Trafalgar (1805), and when one sees pictures of these and other sea struggles it is a dull mind that does not marvel at the beauty and grandeur of a naval conflict in the days of sail, in spite of being aware of the carnage and human suffering that occurred during them. Although twentieth-century naval war is at least as deadly, the shapes of modern ships do not offer the same magnificence as HMS *Victory* and her kind.

In this book are to be found not only pictures of the great and glamorous, however, but a cross-section of the many fine works depicting the world of the fisherman and the coaster, and the harbours in which they sheltered. With both little-known marine artists and illustrious names — Turner, Pocock, Cotman, Wyllie and many others — well represented throughout the volume, it will give pleasure to maritime art lovers and collectors, to professional painters, to all those who love to go down to the sea in ships, and indeed to the many who perhaps have only a pinch of salt in their blood.

John Worsley
PRSMA

INTRODUCTION
The Marine Painting Tradition

A love of the sea and anything to do with it has always been one of Britain's national characteristics, and never more so than in the nineteenth century, when she was at the height of her maritime power. It was a century when the mere sight of a ship going by in full sail was enough to create a surge of patriotic feeling in the hearts of most Englishmen.

Ships and those who sailed in them began to be commemorated in dozens of different ways. The sailor, admired for his manly virtues, was the subject of sentimental poems and music-hall songs, with his figure gracing thousands of mantelpieces in the shape of a piece of Staffordshire pottery, while the ships themselves were to be found on pot lids, silk-woven bookmarks, embroidered in Berlin woolwork, or their replicas made in spun glass and sold in fairgrounds. This vogue continued undiminished until the coming of the ironclads lessened the glamour that had surrounded the old sailing ships.

This renewed public interest in anything to do with the sea gave an enormous impetus to maritime art which, hitherto, had been languishing in the doldrums. Becalmed in the traditional Dutch School of formalised painting which had been with us since the latter part of the seventeenth century, it had tended to concentrate on storm-tossed ships and especially naval battles, a subject which had been fostered by many sea captains who had employed a professional artist to record their ship going into battle with her guns blazing. These pictures of some man-of-war pulverising an enemy vessel may have produced a gratifying record for a sea captain to hang on his wall, but they had done nothing to vary the monotony of marine painting.

The changes that were about to take place in maritime art in the nineteenth century came at an opportune moment. Those who could appreciate the quality of those late seventeenth- and eighteenth-century paintings had, nevertheless, become a little bored with looking at one naval engagement after another and were now seeking something different to hang on their walls. To support them a new market had come into being, initiated by the growing influence of the middle classes who liked marine paintings but wanted more choice of subject. These needs were about to be satisfied by a large army of marine artists which was beginning to emerge, many of whom were highly gifted amateurs who had studied briefly under well-known artists who, more often than not, taught in order to make ends meet. Many of these new painters preferred to work in watercolours, a rather neglected medium until now.

The subjects they chose were often quite homely ones, such as barges making their way along the Thames, rakish small vessels skimming the waters, or fishing boats bringing home their catch — subjects most people could respond to far more readily than those of the Dutch School. There was also much more emphasis on the sailors themselves, often seen struggling against the elements, which appealed to the Victorians' love of melodrama, reflected in much of the work of the contemporary genre artists.

Not that the Dutch style of marine painting was entirely abandoned; and rightly so. For the most part, superbly painted, with every sail and piece of rigging in its exact place, they represent a form of art to which British maritime painting owes its very origins and whose

influence can be seen to this very day.

The birth of this first school of English maritime paintings began in 1672, with the arrival in England of two *émigré* Dutch painters named Willem Van de Velde the Elder (1611–93) and his son of the same name known as the Younger (1633–1707). Almost as soon as they arrived they came under the patronage of King Charles II, who was already well acquainted with their work. In 1674 he appointed them as his official painters and installed them in the Queen's House at Greenwich, from where they were to dominate English maritime art for the next twenty years until the death of William the Elder.

When William the Younger died in his turn, the Dutch tradition of painting was carried on by a number of English artists, including Samuel Scott (1701–72) who, although a maritime painter, only made one sea voyage in his whole life, Peter Monamy (1681–1749), whose only formal art training was as a house decorator, Charles Brooking (1723–59) who excelled in painting naval manoeuvres and died in poverty of consumption, and John Cleveley the Elder (1712–72) who had the deplorable habit of frequently copying his own work. To this list should be added the names of Dominic Serres the Elder (1722–93), a Gascon who settled over here and became a painter instead of a priest, as his family had intended, his sons Dominic Serres the Younger (1761–1804) and John Thomas Serres (1759–1825) the elder brother, whose work is represented on page 32 as one of the first of the maritime artists who straddled the eighteenth and nineteenth centuries.

One of the first true nineteenth-century marine watercolour artists of any real note was the tragically short-

William Edward Atkins (c. 1842–1910), *The Harbour Entrance Portsmouth*. 7½in x 16½in. A fine example of the work of William Atkins, the youngest son of George Henry Atkins (1811–72), a well-known marine artist. William specialised in painting portraits of naval ships and was the naval correspondent and marine artist for the *Graphic* in the 1870s. He lived and died in Portsmouth, and his work can be seen in the local art gallery, as well as in the National Maritime Museum at Greenwich.

lived Richard Parkes Bonington (1802–28) whose paintings are often suffused with a poetic quality rarely seen in the work of marine artists. His legacy of shipping on sunlit water, silvery rivers and mirror-like seas, show us a master of the watercolour technique at work, and one can only regret his premature passing with his life's work barely begun. His last years were spent in a final burst of feverish activity, as if he were trying to get as much painting done as possible before he succumbed to tuberculosis. He was still attempting to paint in the last months of his life when he was too weak to move from his chair.

'His early death was a very great loss to art, for, had he lived, I feel convinced that he would have become one of the greatest marine artists of his time, or indeed of any time.' These words were written by the artist Thomas Sidney Cooper in his autobiography, when commenting on the work of George Chambers (1803–40), another very early nineteenth-century artist, who also died young.

Cooper was not suitably qualified to make this sort of comment with any authority as he was not a marine artist with any knowledge of shipping but one who had specialised in painting sheep and cattle, and whose work had become facile and repetitious when these words were published, more than fifty years after Chambers's death. Even so, one can see why he was so impressed. Anyone with half an eye for a painting has only to look at Chambers's watercolour, *A Merchantman Entering Port on a Strong Breeze* on page 48 to see that one is in the presence of a major maritime artist.

Chambers's story is a remarkable one. Brought up in a squalid tenement in the Yorkshire fishing town of Whitby, where the biting winter winds whistled among the near derelict buildings in the shadow of the old abbey ruins, his very early life was a harrowing saga of abject poverty and harsh treatment which was to contribute in no small measure to his untimely death at the age of thirty-six. Despite this unpromising beginning, at the age of twenty-seven Chambers found himself being summoned to Windsor Castle to show some of his marine paintings to William IV and Queen Adelaide, after he had been brought to their attention by a number of their admirals who had also taken an interest in his work.

Chambers's meeting with their majesties must be one of the very few occasions, if not the only one, when someone turned down an offer to stay the night in Windsor Castle — something which would have made a good talking point when among friends. Instead, when William graciously offered him accommodation for the night, he turned down the offer, saying that he thought he would be comfortable at the local inn — a remark which must have slightly disconcerted the royal couple. Nevertheless, it did not stop the king from commissioning four marine paintings from Chambers, which are still in the Royal Collection.

George Chambers died three years after John Constable (1776–1837). Probably the best loved of all English artists, Constable's name has always been associated with all that is best in the genre of landscape painting. What seems less generally well known is that he was also an outstanding marine artist whose major contribution to this form of art was the way he was able to capture the movements of cloud across the sky or the drama of a storm coming in from the sea. His ability to convey in oil or watercolour these changing moods of the sky derived

from the days when he had studied the clouds for hours on end after his father had made him look after the two windmills the family owned at East Bergholt.

Constable's work was never truly appreciated in his lifetime. The purchaser of the first picture he painted went as far as to have another artist paint out the sky, while the critics often dismissed his work as being crude and rough in finish. One of his watercolours, *Folkstone*, is reproduced on page 51. It is owned by the British Museum, but is never on public display.

If he had not received a couple of legacies of £4,000 each in 1819, his life might well have followed the all-too-familiar pattern of yet another talented artist going through the whole of his life bedevilled by financial worries. As it happened, in the same year he was elected to the associateship of the Royal Academy and about that time began to have some modest success in selling his pictures. None of these unexpected bonuses stopped him from continuing to worry about his health, his financial position and his lack of fame. He does seem to have complained unduly about his lot, though he had some cause when it came to the general lack of understanding of his work, which was better appreciated in France than in England.

A further legacy of £20,000 from his father-in-law in 1828 would no doubt have cheered him up immensely had his wife not died in the same year. It was a shock from which he was never to recover.

Constable was not alone in his misfortunes. Many of the nineteenth-century artists died young or in dire poverty. Those who were painting in the very early years of the century came on the scene a little too late to reap the full benefit of something that occurred in 1804, which was to be of great importance to *all* watercolour artists.

This was the formation of the Old Watercolour Society, in response to the need of watercolour artists to be fairly represented — something the Royal Academy had failed to do for them in its early days, with its habit of cramming all its watercolours in one small ill-lit room where they had to compete with the large number of inferior oils which the Academy was in the habit of banishing from the main salon whenever it was short of space.

The formation of the Old Watercolour Society helped the plight of the watercolour artists, but they still had to compete against the work of oil painters, whose work was also exhibited by the Society. In 1820, however, the Society decided to devote itself exclusively to exhibiting watercolours, and in the following year issued a manifesto which included these significant words: 'Painting in Water-colours may justly be regarded as a new art and in its present application, the invention of British artists; considerations which ought to have some influence on its public estimation and encouragement.'

Two years later, with a new exhibition gallery in Pall Mall East, and thanks to the efforts of the Society, watercolour artists were now beginning to take their rightful place in the world of art. In 1881 the Old Water-colour Society became the Royal Society of Painters in Water Colours, and prospers to this day at Bankside Gallery, 48 Hopton Street, Blackfriars, London SE1.

While all this was going on in London, much was also taking place in the world of art in the provinces, and nowhere more so at the turn of the century than in Norwich, a city that prided itself on its cultivation of the arts. It was from the ranks of its local painters that the famous Norwich School came into being, when sixteen enthusiastic artists, led by John Crome, came together to form the Norwich School of Artists which met once a fortnight in Little Cockey Lane, which ran parallel between Brideswell Lane and St John's Street but was to disappear during one of the many changes that took place in the city over the years.

All the members were primarily landscape artists who produced the occasional maritime painting. Two of them, however, produced a large number of marine water-colours, and therefore deserve special mention.

John Sell Cotman (1782–1842), who spent much of his life in Yarmouth, is the better known of the two. The son of a silk merchant, Cotman was nearly deflected from the course he had set himself on as a painter when his father consulted the famous portrait painter John Opie as to the advisability of his son becoming a painter. Opie's advice was brief and to the point. 'Let him black boots rather than follow the profession of an artist.' Fortunately for us, if not for Cotman, the advice was ignored.

As it happened, there must indeed have been times when Cotman was to remember Opie's words and wished he had taken his advice. After going to London, where he spent several wasted years getting nowhere with his art, he returned to Norwich in 1806 where he toiled unceasingly, fighting to support himself and his family in the face of the critics' opinion of his work, which was seldom more than lukewarm. Driven to giving drawing lessons, a way of earning money which he detested, he seems to have lurched from one financial crisis to another, growing ever more despondent with the passing years.

'My views in life are so completely blasted that I sink under the repeated and constant exertion of mind and body', he wrote to a friend.

Every effort has been tried, even without hope of success. Hence the loss of spirits amounting almost to despair. My eldest son, who is following the same miserable profession as myself, feels the same hopelessness with myself; and his powers, once so promising, are evidently paralysed, and his health and spirits gone. My amiable and deserving wife bears her part with fortitude — but the worm is there. My children cannot but feel the contagion.

In the face of such misery it seems heartless to add that if he had not chosen to have five children, his burden would have been less. His work is illustrated on page 54.

The only other artist of the Norwich School who could be known as something more than merely an occasional painter of marine watercolours was Joseph Stannard (1797–1830), who took the subject so seriously that he made a trip to Holland especially to study the work of the Dutch Masters. The result was that some of his sea pieces bear a close affinity to their paintings, especially that of the Van de Veldes. His style is noted for its fine draughtsmanship and excellent figure work. Like so many of his fellow artists, however, his work was not appreciated in his time, but this may well be because he died at the age of thirty-three and his output was small.

Which brings us to that turning point in the history of British art when Joseph Mallord William Turner (1775–1851) arrived on the scene to upset all the previous conceptions of how a picture should be painted.

A great deal has been written about Turner's work. In his own time, when critics were given to filling column after column with flowery effusions about some artist's affinity to God, Nature or the sea, much of what was written was worthless as criticism, and in most cases merely served to gratify the painter's vanity. In Turner's case, however, the critics were often downright hostile which gave him a great deal of unhappiness, so much so that John Ruskin, who was to become the leading art critic of his time, felt impelled to write a spirited defence of Turner's work in the first of his five volumes of *Modern Painters*, which appeared in 1843.

As well as being hurt, Turner must have been angered by the critics' cavalier attitude towards him and their refusal to take his work seriously, even though his commitment to his art had clearly never been less than complete. Very few artists, if any, would have had themselves tied to the mast of a packet boat during a storm in order to record the fury of the elements, as Turner did when he painted his *Snow-storm: steam-boat off a harbour's mouth making signals in shallow water, and going by the lead.*

This commitment to his art had been with him even in his early life. When carrying out a commission to supply *Copper-Plate Magazine* with a large number of topographical drawings, he would think nothing of walking from twenty to twenty-five miles a day, carrying his baggage on the end of a stick and making notes and sketches on the way. On those days he rose early and worked hard all day, industriously recording castles and abbeys as he went, making do with simple meals and seeking out whatever accommodation he could find in the evenings, however rough it might be. The following year found him carrying out a similar commission, this time supplying drawings for *Pocket Magazine,* and in the process travelling over much of England and Wales.

It was not until he abandoned this type of work that he began to emerge as an artist with those visionary faculties that were to become his hallmark in later years. His continuing obsession for work took him far and wide, first to Scotland and then to the Continent, where he painted his well-known *Calais Pier,* which eventually went to the National Gallery.

As the years went by and his powers matured, his work began to show a heightened sense of colour, gradually increasing in richness and reaching its culmination with such painting as *The Fighting Teremaire,* which belongs to his middle period and is considered by many to be one of his finest works. Anyone who has seen this picture of one of the old three-decker ships being towed along by a steam tug to its final berth to be broken up, with a deep red sun setting in a bank of cloud and mist in the background, would have difficulty in disagreeing with this opinion.

It is from this point onwards that Turner's preoccupation with work seems to have become quite obsessional. Between 1829 and 1839 he painted fifty-five pictures for the Royal Academy, made more than four hundred drawings for the engravers, and produced thousands of sketches, as well as carrying out a large number of private commissions.

It has been said that he was driven by avarice, and many stories were circulated at the time to support this. But no concrete evidence has ever been supplied that his obsession to paint came from a desire to make money from his art. And even if it were true, who could blame him for trying to get the better of some hostile dealer who was trying to buy his work at a rock-bottom price if he could get away with it?

In other areas he could certainly be generous. In later years, when the tenants of his Harley Street house were in arrears with their rent over a long period of time, he prevented his lawyers from serving them with eviction notices. 'Keep the money and use it to send your children to school and to church', were the words he used when he declined repayments of a large sum of money from the widow of a poor drawing master who had borrowed it from him. On another occasion he withdrew one of his pictures from the walls of the Academy to make room for an unknown artist. The recorded acts of generosity seem to have been numerous.

It was John Ruskin, who had written so much about Turner the artist, who was to have the last word on Turner the man.

During the ten years I knew him, years in which he was suffering from the evil-speaking of the world, I never heard him say one depreciating word of any man or man's work; I never saw him look an unkind or blameful look; I never knew him let pass, without sorrowful remonstrances or endeavour at mitigation, a blameful word spoken by another. Of no man, but Turner, whom I have known could I say this.

In his private life Turner had always been something of a recluse. When he became an Academician, he took his father to live with him in his home at 11 Harley Street, London W1, where they lived together for nearly thirty years. The father made himself useful in various ways. He prepared and strained his son's canvases, a full-time job in itself one would have thought, considering Turner's enormous output. In addition he supervised the preparation of the meals and showed visitors around the gallery, which Turner had opened in his house in the hope that a closer acquaintance with his work might counteract to some degree the constant virulent attacks on his paintings. One way and another, Turner senior seems to have earned his keep.

When his father died in 1830 Turner retreated more into himself, living a life of almost complete isolation, retiring to a home he had built for himself in Twickenham

Scheveningen boat

Norfolk wherry

as far back as 1811. He stayed there until the last stages of his life when he moved into lodgings at 11 Cheyne Walk, Chelsea. The last picture we have of him is of his short sailor-like figure going out on one of his solitary walks, watched by some of the local children to whom he was known as Admiral Booth, probably because the word had got around that he was an impoverished naval officer.

Although it is now generally accepted that Turner was the greatest of all the English marine artists, his work is still not to everyone's liking. Even today, when we have much more understanding of what he was trying to achieve when he painted, there are still many who prefer the conventional and tightly executed marine painting in which the Van de Veldes excelled. Some have even claimed that his influence was actually detrimental to English maritime painting. This is debatable, but there is no doubt that his work has been allowed to overshadow that of many other fine marine watercolour artists.

The Turner watercolour which is reproduced on page 91 is an example of his late work. It is a very rare and valuable painting which came up for sale at Phillips, the auctioneers, on 18 April, 1988, when it was bought under the hammer by a German industrialist for £400,000. It came from the family of Thomas Griffith, Turner's agent. It depicts the *Grand Canal with the Church of Santa Maria della Salute*, and shows Turner the Impressionist at work.

Only two years before Turner's death in 1851, a cholera epidemic had raged through the city of Hull, killing off some two thousand of its inhabitants. One of them was a marine artist named John Ward (1798–1849) who had died within hours of being struck down — just one of the 53,293 people who died in England and Wales that year from the dreadful scourge.

His death may not have been of such great note in the art world as Turner's had been, but it did have some bearing on the history of marine watercolour painting, as it saw the premature passing of the leader of the Hull School of Maritime Painting, founded by Ward from the ranks of those who came to him for tuition in maritime painting. Greatly influenced by the work of the Scottish artist William Anderson who had visited Hull, he painted many excellent marine watercolours which ranged from ship portraits to scenes along the Humber.

Others who belonged to the Hull School included William Daniel Penny (1834–1924), who originally came from Caistor in Lincolnshire and settled in Hull around 1860, where he worked for the next forty years. After-

wards he moved to Aldborough in the Vale of York, where he ran an inn called *The Artists' Rest*, before retiring to end his days in a cottage in the local High Street.

Among the rest of the well-known and not so well-known Hull artists were Henry Redmore (1820–87), a marine engineer who painted in the style of the Dutch School, Frederick Settle (1821–97), who is known to have taken time out from his marine painting to do some originals for Queen Victoria for use as Christmas cards, and James Wheldon (fl.1863–76), who was working during the last years of the Hull whaling trade when he painted a large number of studies of a ship called the *Diana*, which he placed against an appropriate but imaginary background of ice floes and frozen seas, with polar bears roaming over the ice pack in the vicinity of the ship.

All these artists, and others of the Hull School, made a valuable contribution to marine painting, especially in the way they depicted local shipping, which has provided a most useful reference to anyone specialising in the subject.

Charles Bentley (1806–54), a talented watercolourist who specialised in river and coastal paintings, was another artist who died of cholera. Considering the lack of sanitation and any true understanding of the need for general hygiene in those days, it is surprising that there were not more deaths from the disease among the marine artists, who frequently mingled with sailors who were notorious carriers of cholera. Even more surprising was its complete eradication from Britain by 1894.

Death may have taken more than its fair share of young marine watercolour artists, but a large number survived to confound what seemed the norm, the most obvious example being John Christian Schetky (1778–1874), who died at the age of ninety-five. Schetky lived long enough to be the official marine artist to George IV, William IV and Queen Victoria.

Known to his friends as 'Sepia Jack' because of his fondness for using a coppery brown wash when painting, Schetky was a genial but slightly bizarre-looking character, immediately recognisable even in the distance by his immense height and the rag-bag of ill-fitting clothes he wore which looked as if 'they had been thrown on him from at least half a mile', according to one of his students at the Portsmouth Naval Academy where he was Drawing Master. Thin to the point of seeming undernourished, he gave the appearance of some absent-minded professor, an appearance quite belied by his bluff manner and penchant for using nautical terms when

addressing his pupils, who were often exhorted to 'Clear the decks!' when he entered the room.

An indomitable character, who obviously did not believe in giving in to age, Schetky made the last of his many visits abroad at the age of eighty-two, in order to sketch along the coasts of Spain and Portugal on the way to Lisbon. The trip was an unqualified success, as he returned with some of the best marine watercolours he had ever done.

Schetky was mostly a ship-portrait painter, who also painted some magnificent battle pieces. His ship portraits belonged to a certain tradition of marine painting that went right back to the latter part of the eighteenth century and continued to be practised to a lesser degree throughout most of the nineteenth. Originally they were done by itinerant artists who touted for work around the shipyard and docks, seeking commissions from naval officers who wanted a painting of the ship on which they were serving. They were generally naïvely done and were almost invariably painted broadside on — a way of looking at a marine subject that served a twofold purpose: the artist was able to show the ship to its best advantage, and it also did away with any problems that might arise with perspective. These artists were popularly called 'Pierhead Artists' because they seldom ventured aboard to paint their ship portraits.

Schetky's work may have stemmed from this tradition of ship-portrait painting but, unlike so many of the latter-day nineteenth-century artists who went in for this type of painting, his work was far too sophisticated and professional-looking for it to be associated in any way with them.

Much nearer to the spirit at least of the early naïve painters was the work of the deaf-mute artist, William Frederick Mitchell (1845–1914), who supported himself almost entirely on ship-portrait painting by haunting the docks of the Royal Naval Dockyard at Portsmouth for commissioned work. Hindered by his afflictions, he made

an arrangement with the owner of a bookshop near the main gates who handled the commissions for him and then took a percentage. But as can be seen from the picture of one of his ship portraits on page 76, his work was far too good in quality for him to be labelled a Pierhead Artist beyond doing all his work from a land viewpoint.

By the time the mid-1850s had been reached there were more marine watercolour artists around than one would have thought possible with a medium that only fifty years before had been rather looked down upon by the Royal Academy, and had been none too popular with many artists who preferred to paint in oils, which gave them a far better chance of having their work exhibited at the Academy.

But now everything had changed. The Royal Academy now actively supported the watercolour artists and taught watercolour painting in their schools, and many artists of note gave lessons in their homes. As has already been noted, the Hull School of Maritime Painting was founded in this manner.

A growing appreciation of art by the general public was also now apparent, thanks in part to the efforts of the Watercolour Society, whose frequent exhibitions had helped to promote watercolours. With all these factors going for them, and the sale of art booming as a result of the growing affluence of the middle classes, the watercolour artist was in a better position than he had ever been in before. This applied to the marine watercolour artists no less than to the landscape and genre painters. Some of them had indeed become well-known figures — something that had seldom occurred in those earlier days.

One of the most popular of these artists was Clarkson Stanfield (1793–1867), whose work had been greatly admired by Constable. Nor had he been alone in his admiration for the work of this artist. Not one single critic or painter of any note seriously questioned his merits, though Ruskin, who seemed to want to have the last word on everybody, did venture to say: 'We should like him to be less clever, and more affecting, less wonderful and more terrible.' Most artists could live with that.

Many of Stanfield's leisure hours were spent in the company of some of the foremost artists and writers of his day. His closest friend was probably Charles Dickens, whom he met when Dickens was indulging his passion for amateur theatricals and was putting on plays in his own home. As Stanfield had been a scenic painter for the famous Drury Lane Theatre at one time, Dickens asked him if he would paint the scenery for some of his plays. Stanfield agreed, and the men soon became firm friends.

In time, they went their different ways, but Dickens never forgot his old friend. *Little Dorrit* was dedicated to him, and when Stanfield died Dickens wrote a touching obituary on him which appeared in the magazine *All the Year Around* which he was editing at the time. In it he referred to Stanfield as being 'the soul of frankness, generosity, the most loving and lovable of men'.

Edward Duncan (1803–82) was also a very popular artist in his time. A landlubber who only made one short sea journey in his life, he nevertheless had the ability to depict the sea in all its moods, especially when at its most treacherous, with the result that many of his paintings were highly emotive ones of ships fighting to keep afloat on storm-tossed seas, or of actual shipwrecks. These subjects appealed to the Victorians' love of dramatic pictures where someone was having a rough time of it, be they of some poor woman being evicted from her home or of a group of sailors being forced to fight for their lives against the elements.

Modern opinion is critical about Duncan's work; and with some cause. Much of it was either sentimental or melodramatic or painted in over-pretty colours. Even the painstaking care he took over his pictures worked against him, as it resulted in a tightness in the execution which often made the final result look more like a well-drawn book illustration than a freely painted oil or watercolour.

For the layman his paintings are fun, and convey more about some of the Victorian attitudes than any picture painted in the Dutch style could do.

Two other popular artists were Thomas Sewell Robins (*c*.1809–80), whose atmospheric marine watercolours were generally of a high quality, many of them in the best traditions of George Chambers, and Edward William Cooke (1811–80), whose work in watercolours was regrettably small, but still rank as some of his best. Exam-

ples of their work can be found on pages 48 and 53 respectively.

It was in the 1850s that the marine watercolour artists were given the opportunity to supplement their incomes in a way that had not been available to them before, except on rare occasions.

The middle of the century had seen the rise of the weekly magazines, whose editors had now begun to call upon artists to supply them with illustrations. Although they drew their contributors mostly from the ranks of the genre and landscape artists, there was still a great deal of work to be had for the marine artists who had already joined in the rush to supply illustrations for the book market which was also booming, thanks to the growing literacy of the working classes and the publishers' new policy of producing cheap reprints of famous books.

In time there was hardly an artist of any note, even in the highly specialised field of marine painting, who did not benefit from this new source of potential income. The importance of these new outlets cannot be stressed enough. For the first time ever, many artists now had a sporting chance of not ending their days in poverty, as had happened to so many of them in the past.

The growing prestige and improved financial situation of many of the English watercolour artists was not reflected in Scotland to the same extent, which did not have its own Society of Painters in Watercolours until 1878, even though watercolour artists had been active there for more than a century. As for the marine artists, *some* of them were doing well enough, but by and large they suffered the same neglect as their brothers over the border had received at the hands of the public nearly fifty years before.

Among those honoured in their own lifetime was Sam Bough (1822–78), one of the best Scottish artists of his time. Primarily a landscape artist who also painted a large number of marine watercolours, the quality of his work was so good that one wonders why his work is not more well known to the general public.

Bough was not strictly a Scot, having been born in Carlisle, but his reputation was made mainly in Scotland and particularly in Edinburgh, where his thickset and poorly dressed figure soon became a familiar sight in the streets of the city after he had settled there in 1855. A born raconteur, whose sharp tongue often made him enemies, he also had a large number of friends, including Robert Louis Stevenson who was to write an obituary on him in which his obvious affection for Bough was tempered with a candid acknowledgement of his faults.

. . . spectacled, burly, in his rough clothes, with his solid, strong and somewhat common gait, his was a figure that commanded notice, even in the street. He affected rude and levelling manners; his geniality was formidable, above all for those whom he considered too fine for their company; and he delivered jests like buffets. He loved to put himself in opposition, to make startling, and even brutal speeches . . .

Stevenson softened his pen portrait by going on to refer to him as being 'a man of warm feelings, notable powers of mind and much culture', as well as speaking of his love of music, dogs and good talk. All the same, a man to move away from hastily if one found oneself standing next to him in a public bar, one would have thought. A striking example of his work is on page 39.

A contemporary of Sam Bough was William McTaggart (1835–1910), one of the major figures in the history of Scottish art. Born into a humble farming family in the Campbeltown area, he started his working life as an apprentice apothecary before eventually going off to seek his fortune as an artist in Edinburgh.

After studying for seven years at the Trustees Academy, his life from the time he left was one of steady progress as an artist. Starting off by painting marine subjects in oils, he turned to watercolour painting, using a fully loaded brush which seemed to liberate his hand in a way that made much of his work almost Impressionistic as he caught light and movement with bold and sure single strokes.

A man who had always loved the sea, he was delighted when he discovered Carnoustie on the east coast, an area well known for its violent storms and powerful gales which provided splendid subject matter for any artist bold enough to brave the elements by painting on the spot, as McTaggart so often did, using only one size of brush in order to capture the immediacy of what he saw without having to pause to change brushes.

Much less well known, but still an interesting and worthwhile marine artist, was James Cassie (1819–79), an Aberdeen man who also painted on the east coast. A far more conventional painter than Bough or McTaggart, his work is still very pleasing to look at, with much of it painted in bright colours. His watercolours were mostly views of the sea or harbours, generally signed with a monogram.

Although there were a number of other marine watercolour painters working in Scotland at the time, particular mention should be made of the Glasgow School,

whose artists were fond of using the 'blottesque' form of painting characterised by the application of large blobs of colour on the paper which merged into a scene when viewed from a distance. A characteristic example of this type of painting can be seen in the work of Robert McGown Coventry (1855–1914) shown on page 55.

Another artist who used the blottesque technique from time to time was James Watterston Herald (1859–1914), who drank himself to death. Born in Forfar, the son of a shoemaker. He spent a number of years south of the border in Croydon, Surrey, before eventually returning to Scotland where he spent the last thirteen years of his life, isolated and ignored, but still painting steadily, while fortifying his spirits with regular intakes of drink which eventually killed him off with cirrhosis of the liver. His demise was hardly noted as by then he had become a recluse and was living in poor circumstances. His watercolour, *On the Sands, Arborath*, which is in the British Museum, is so modern-looking that it could have been painted well into the twentieth century.

Scotland's contribution to marine painting was an important one. While most English artists of that period were content to follow the familiar and safe styles of the earlier English marine artists, many of the Scottish painters were seeking to paint their watercolours in a freer style. To achieve the fluidity they sought, they relied greatly on the French *plein air* method of painting, which was executed in the open air, either from the beach or from a boat as McTaggart had done, moving from sketch to finished drawing in one session.

Henry Eustace Tozer (fl. 1889–92), *Tug at Sea*. 7in x 22¾in, J. Collins & Son. Tozer lived in Cape Cornwall House, St Just, near Penzance. He specialised in painting coastal and marine subjects, unlike his brother E. Arthur Tozer who painted moorland scenes. Very little is known about him except that he exhibited twice at the Royal Society of Artists and once at the Royal Academy.

An advert for the Christmas number of the *Yachtsman* 1896, a magazine that would have been bought by such artists as Charles Gregory, Charles Napier Hemy and Henry Scott Tuke, who were all keen yachting men. (Peter Ferguson Collection)

John Brett (Jeremy Maas Collection)

Henry Moore (Jeremy Maas Collection)

Changes *were* taking place in English marine water-colour painting, but these were more to do with subject matter than style. These changes in taste were occasioned to some extent by the constantly growing number of people who had money to spend on making the interiors of their homes more attractive to live in. Much in the same way that people had turned away from the Dutch School of painting, people were now less inclined to have some gloomy picture of a ship battling its way through a storm on their walls. Instead, bright and cheerful subjects were now much more the order of the day, with some of the popular subjects being ships sailing on tranquil waters against the warm glow of a setting sun, or of fishermen bringing in their catch. Now also much in evidence were gleaming white yachts moving over sun-dappled waters. Charles Gregory (1810–96), who lived in Cowes, made a good living from this sort of watercolour, often with the Cowes Yacht Club as part of the scene, as in his water-colour on page 65.

One of the few experimental English marine artists of the period was Henry Moore (1831–95), who began his career painting landscapes. Like McTaggart, he used a bold free style, often employing a rich blue which became so characteristic of his work that one French critic referred to it as *'la note blue de Moore'*. As a sea painter he has come to be regarded as being almost without equal.

By the 1870s the approach to marine watercolour painting had not changed greatly, though inevitably a few new reputations had been made. John Brett, Charles Napier Hemy, Arthur Joseph Meadows and William Lionel Wyllie were just a few of the new watercolour artists whose work had now become known to the public. All of them were still working in the early years of the twentieth century.

John Brett (1830–1902) was an artist who, like Henry Moore, had started off as a landscape painter before turning to painting in oils and watercolour a whole series of marine subjects while sailing up and down the south coast in his yacht, with the occasional foray to the Channel Islands.

In his private life, Brett was an eccentric with an obsessional preoccupation with astronomy. In 1880 he had a special house built for him in Putney which contained a central pillar that ran right through the building, culminating in an observation post in which his telescope was housed. The floors throughout were made of a special substance which made them easy to clean, and there were no doors to any of the rooms. For no discernible reason his seven children were actively discouraged from wearing any clothes in the house. Something of his obsessional attitude towards his hobby carried over into his work. His watercolours were the product of a mind intent on observing the exact movement of every ripple or wave of the sea with an exactitude that tended to make some of his pictures overworked. It has to be added that later he was to break away from this restricting formula by aiming for a freer style, when his cloud formations were laid down in a manner reminiscent of Constable.

Charles Napier Hemy (1841–1917) was another interesting character, inasmuch as he started off his adult life by entering a Dominican monastery in Newcastle with the intention of becoming a monk. Later, he was sent on to another branch of the Order in Lyons, where the disciplines imposed on him there seem to have weakened his resolve to take his final vows. He left the Order at the age of twenty-two to embark on a path which was to make him one of the best known marine painters of his time (see page 69 for an example of his work).

Arthur Joseph Meadows (1843–1907) was one of the three sons of James Meadows (1798–1864), an excellent marine artist himself who had exhibited regularly at the Royal Academy between 1855 and 1863. Arthur Joseph was an admirer of the work of Clarkson Stanfield, whose style he so openly imitated. Like most marine artists he painted both in oils and watercolours, searching for his subject matter along the coasts of England, France, Holland and the Mediterranean, where he used a strong blue for the skies and seas. Otherwise he used pleasing pastel colours which won him a large number of admirers.

With William Lionel Wyllie (1851–1931) we have an artist whose work embraced the High Noon of Empire and its passing, which he caught in the two magnificent watercolours which are reproduced on page 94. A pupil of Charles Napier Hemy, he was one of the most talented and certainly the most prolific artist of his day, equally at home as an etcher, a painter in oils and, above all, as a watercolour artist.

His output was truly enormous, so much so that when he died, five thousand watercolours were found in his home which were bought for the proposed Maritime Museum at Greenwich, which was opened in 1937. This

does not take into account all the work he had sold, to say nothing of the countless illustrations he had done for the *Graphic* during a tenure there as its marine illustrator, nor the large number of illustrations he drew and painted for innumerable books, including one on the Thames and another with the intriguing title *Nature's Laws and the Making of Pictures*.

With the old century now coming to its close it seemed that marine painting had nothing more to offer the world. A few token nods had been made in the direction of the Pre-Raphaelites, whose use of bold, bright colours had briefly appealed to artists like John Brett and Henry Moore; and Impresionism was also beginning to acquire its devotees. But there had not been enough of them to make any major impact on marine watercolour painting — at least not in Britain, where the genre remained essentially rooted in the old romantic traditions of maritime painting.

But there was to be an unexpected development towards the tail end of the century, which was to have an enormous impact on the art world. This was the belated discovery by the critics that a school of talented artists, working in both oils and watercolours, had been busily painting away since 1882 in the charming Cornish fishing village of Newlyn.

In some way it is surprising that the movement received the attention it did at the time. Even the artist Stanhope Forbes, who had started the furore when his painting *A Fish Sale on a Cornish Beach* was shown at the Royal Academy in 1885, admitted that the movement was in no way innovative, and had come about merely because a number of artists had got together who believed implicitly in the importance of painting in the open air. In this, of course, they were merely following an already well-trodden path taken by *pleinairistes* such as McTaggart and the others who had first discovered the value of painting outdoors.

Where the Newlyn artists *did* differ was in their choice of location, their common enthusiasm for the locale where they worked, and the extraordinary quality of most of their paintings.

As a location, Newlyn was the perfect place to work for artists of this nature. A village of narrow cobbled streets with pretty whitewashed houses, occupied by fishermen and their wives whose lives were governed by the mackerel, pilchard and herring seasons — what artist could ask for more if he liked painting the sea and those who lived off it? Some concentrated on recording the domestic lives of the local fisherfolk, while others were

Theodore Weber (1838–1907), *Fishing Boats Returning*. 12½in x 21¼in, Sotheby's, Billingshurst. This is a deceptively simple watercolour in which the English boats returning home stand out starkly against the sky and sea. A little-known but very talented artist, Weber was not, strictly speaking, an Englishman: he was born in Leipzig, studied in Bonn, and his main residence for most of his life was in Paris. However, a great deal of his work seems to have been done in Britain and he is included in the reference books of English maritime painters. He exhibited five times at the RA, and his work can be seen in the Tate Galley, the Nottingham Art Gallery and the Laing Galley in Sheffield.

Arthur Joseph Meadows (1843–1907), *Nr. Middleburg – After a Shower, South Holland,* 1884. 9½ x 13½in, Sotheby's, Billingshurst. Arthur Joseph Meadows was probably the best known and most popular of this family of marine artists. Although he had no formal training, Meadows became an excellent and renowned maritime painter whose pictures went in auction for anything up to £50 — a handsome price in those days. He lived in London for much of his life, but once he had become established he went down to Devon so that he could study the local shipping. In middle age he also journeyed to Italy, France and Holland to paint. This picture was one of the products of his travels.

more interested in the activities of the fishing fleet, which often did not return until months later, when the sight of their sails on the horizon brought the women hurrying down to the beach to greet the homecoming fleet. Wonderful material for any marine artist!

The first artist to arrive in Newlyn was Walter Langley (1852–1922). A Birmingham man who had started off as a lithographer before turning to painting, he was settled in a house in Newlyn and working there by 1882. Others quickly followed him, as if summoned by some sort of bush telegraph, including Henry Scott Tuke (1858–1929), who became a friend and admirer of Langley, whom he considered 'the strongest water-colour man in Europe'.

Tuke was a highly talented watercolour artist himself. By the time he went to Newlyn he was already a well-known and respected painter, although his career had got off to a bad start when the Royal Academy rejected his first submission, causing him to comment sourly, 'It is not to be wondered at when the hanging committee consists of men going downhill and two already at the bottom.' In the long run he had no real cause for complaint of his treatment at the hands of the Academy, as it was to exhibit forty-three of his pictures over the years.

After he was settled in Newlyn, Tuke bought himself a French brigantine in which he created a large studio with a glass roof which was to be the envy of all his friends, and gave him an excellent opportunity to sail in close to many of the ships and boats he wanted to paint. A case in point must have occurred when he painted his watercolour *A Gaff-Rigged Cutter Under Sail* shown on page 89.

Although he also worked in oils, Tuke was primarily a watercolour artist who liked to paint ships bathed in a shimmering light. He also had the quite innocent habit of painting naked youths bathing off the beach, which must surely have raised an eyebrow or two among his friends. In the London exhibition rooms they were something of a scandal.

Apart from Tuke, Walter Langley and Ralph Todd, there were a number of other well-known artists who belonged to the Newlyn School, including Edwin Harris (1855–1906) who came to Newlyn in 1883. Another Birmingham man, who had studied at the Birmingham School of Art and had only begun to exhibit at the Royal Academy the year before he arrived in Newlyn, he seems to have made no attempt to capture the spirit of this hard-working fishing village but to have concentrated instead on painting winsome-looking girls sitting in the window

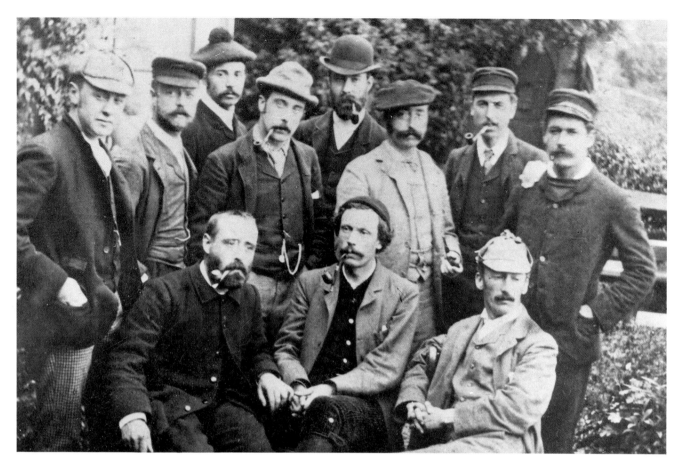

of some modestly furnished cottage, whose genteel appearances were very much at odds with the down-to-earth life of the local fishing folk. He stayed in Newlyn for twelve years, long enough to see his son born and his wife die of a painful illness, before he left the village and became a portrait painter in Cardiff, Newport and Bristol. He went back to his roots in Birmingham to die.

Another familiar Newlyn name was that of Fred Hall (1860–1948). He was also an excellent cartoonist who did some marvellous silhouettes of some of his fellow artists in Newlyn. Unlike Harris, he was a *plein air* painter; he sometimes lowered his own standards by pandering to that section of the Victorian public which believed that every picture should tell a story, a view far removed from the growing tendency for artists to paint in the Impressionistic manner. His often sentimental approach was shared by a number of the Newlyn artists including Stanhope Forbes himself, whose painting *The Health of the Bride* is a marvellously observed piece of work, but still belongs very much to the Victorian style of genre painting.

Another of the School was Percy Craft (1856–1934), whose painting *Heva! Heva!* was well received when it appeared and which shows the frantic activity that went on in the village when the word was passed around that the seasonal shoals of pilchards had arrived. But unfortunately, like a number of his other subjects, it is not very well painted. One exception to this generalisation, however, is *Tucking a School of Pilchards on the Cornish Coast*. This splendid piece of work, painted in 1897, is full of carefully observed detail and contains magnificent studies of the faces of some of the fishermen.

One of the more interesting members of the Newlyn School was Frank Bramley (1857–1915), a melancholy-looking man, who was the local leading exponent of the square brush treatment. Sadly, his last days were spent far from his beloved Newlyn, trapped in a flat in London with a crippling illness which eventually killed him. Henry Meynell Rheam (1859–1920) was another artist of the School, a well-known local cricketer who had been living in Polperro until the Newlyn Cricket team lured him there to join their side. Primarily a water-colour artist, his work has appeared regularly in the auction rooms since the early 1980s. And, of course, there was Elizabeth

Forbes, who settled in Newlyn in 1883, where she met Stanhope Forbes in the house of Edwin Harris, and married him after a whirlwind courtship.

Stanhope Forbes is always referred to as the founder of the School, but this is not strictly true as he did not arrive in Newlyn until 1884. Forbes himself denied he was the founder, seeing the movement as nothing more than a group of artists who happened to share a common ideal. But it was Forbes whose work had attracted attention to the Newlyn artists in the first place, Forbes who helped to keep them together as a closely knit community, and Forbes, together with his wife, who tried to maintain the ideals of the Newlyn School by opening a school for painters in 1899, when many of the original Newlyn artists had already left. If not their founder, he was certainly their guide and mentor.

Forbes's own devotion to Newlyn was so strong that he stayed on there to the very end of his life which ended when he was ninety, on 2 March 1947.

With his passing it must have seemed to many that at last the great age of marine painting had come to an end.

But they were to be proved wrong. A new school of marine artists was to appear in the twentieth century, as talented as those of the nineteenth century, but often owing little to the old traditions of maritime art. This was mainly because of the very nature of their subject matter, which was vastly different from that of the nineteenth century marine artists who had only to look around them to find an enormous variety of sailing ships to paint. The modern artist going out to sea in search of a subject is far more likely to encounter an ocean-going liner, or a super-tanker ponderously ploughing its way through the waves, than a ship in full sail. Hydrofoils skimming the waters, a submarine breaking surface or an oil rig in the North Sea emerging out of the ocean like some monstrous creature from the deep — these are the sort of subjects you are likely to find in modern maritime art. The result has been that many such paintings have ended up on the wall of some boardroom, rather than in private houses.

A number of artists have become only too conscious of the limitations that have been placed on them by the sheer ugliness of much of the shipping to be found in the sea lanes. John Worsley, a distinguished modern marine

painter and President of the Royal Society of Marine Artists, has gone on record as saying that he became disenchanted with painting modern ships, which he saw as nothing more than enormous tin boxes. His growing distaste for them prompted him to seek new pastures for a while, painting the junks in Hong Kong and the old-style fishing trawlers sailing in and out of Aberdeen. Others have tried to solve the problem by following the examples of those artists who spanned the nineteenth and twentieth centuries and merely continued to paint the old sailing ships. Montague Dawson is a typical example.

What is missing, of course, from much modern marine painting is the sense of romance and adventure that is so apparent in most nineteenth-century maritime art. But then, the marine artists of those days were only too well aware that they were often painting ships that were sailing into vast oceans with little more than a compass and sextant and some maps to guide them to their destination. One must remember, too, that these were the days when drowning at sea was a common occurrence. It did not

take much: a fall from the yardarm or a careless step on deck during a strong gale or storm was enough to lead to a watery grave. Even sailing in coastal waters had its dangers, as many of the small craft were leaky affairs, capable of sinking to the bottom of the ocean at any moment. Every voyage for any sort of vessel was therefore something of a hazardous adventure, a fact that was fully appreciated by all the marine artists of those times, many of whom had been sailors themselves or had lost a relative at sea. Something of this awareness is caught in the shipwrecks and sailing ships wallowing dangerously in high seas, which are found in some nineteenth-century maritime art.

The nineteenth-century painters were very much products of their time, with their own special problems, which included having to break free from the constraint laid upon them by the formalised school of Dutch painting in which waves often marched across the canvas or paper in an orderly procession, with little relation to the way in which the sea actually moves. In addition, water-

colourists had to overcome the public's indifference to watercolour painting in general — something that had seemed a hopeless task until the Society of Watercolours took up their cause. Grinding poverty, ill health and the frequent hostility of the critics were other factors against which many of them had to fight for most of their lives. That they managed to overcome obstacles of this nature and become a major force in English art is testimony to the quality of much of their painting.

What the future holds for the twentieth-century maritime artists who have followed them is anybody's guess. In time, their choice of subject matter may seem just as interesting and glamorous as the old sailing ships are to us now. If the prices that many of them are now fetching in the auction rooms today is any guide, they have already established themselves in the marketplace.

Whether or not they will ever be regarded with the same affection and admiration as those nineteenth-century artists whose work is represented in this book is another matter.

THE ARTISTS:
Brief Biographies

ABBREVIATIONS

exh.	exhibited	RA	Royal Academy (Academician)	RSA	Royal Scottish Academy
fl.	flourished	RBA	Royal Society of British Artists	RSW	Royal Scottish Society of Painters in Watercolours
ARSA	Associate of the Royal Scottish Academy	RBSA	Royal Birmingham Society of Artists	RWA	Royal West of England Academy
BI	British Institution	RCA	Royal College of Art	RWS	Royal Society of Painters in Watercolours
NWS	New Society of Painters in Watercolours	RHA	Royal Hibernian Academy	SS	Suffolk Street Galleries
OWS	Old Society of Painters in Watercolours	RI	Royal Institute of Painters in Watercolours		

FREDERICK JAMES ALDRIDGE
1850–1933

Aldridge was an artist from Worthing, where he lived for the whole of his life, as well as being associated for a long time with a firm of art dealers which traded under his name. He painted mainly along the Channel coastline.

He was a regular visitor to Cowes Week for fifty years, a favourite meeting place for like-minded artists of the period. He exhibited at most of the London galleries from 1880 to the turn of the century.

ROBERT ANDERSON, ARSA, RSW
1842–85

Anderson was a Scottish artist from Edinburgh, who was originally a line engraver, and who acquired considerable reputation in this field before he suddenly turned to watercolour painting. He was a popular artist in his lifetime, who was known for his large watercolours of fishing boats and fishermen, and for some of his coastal scenes. Today, for some inexplicable reason, his work seems to be almost forgotten.

ALEXANDER BALLINGALL
fl. 1880–1910

A Scottish marine watercolour artist from Edinburgh who specialised in painting views of the harbours and their shipping along the east coast. He often worked on a large scale, which gave him the opportunity to show in great detail the rigging of a ship. In many ways his work resembled that of J. D. Taylor (fl. 1875–1900), whose watercolours were also highly detailed.

CHARLES BENTLEY, OWS
1806–54

Bentley was born in Tottenham Court Road, London, where his father was a master carpenter. The son was apprenticed to an engraver named Theodore Fielding, for whom he did some plates, including a number from the work of Richard Parkes Bonington, who was to have a great influence on his own work.

Always at the mercy of the dealers, who seem to have been a far less gentlemanly and honest band of people than those of today, he never did more than scrape a living from his painting until the day of his death of cholera in London at 11 Mornington Place, Hampstead Road, leaving behind him a widow and a very aged mother, who lived in Boston, Lincolnshire. Both of them had been more or less dependent on him.

SAM BOUGH, RSA, RA
1822–78

Born in Carlisle on 8 January, Bough started off his painting career as a landscape painter before becoming a marine artist in the 1850s, when he quickly added to what was already a formidable reputation as a watercolour artist.

The son of a cobbler, and one of a family of five, he was put to work in a solicitor's office at the age of fifteen. When this proved to be something of a disaster, he was sent to London to learn engraving. This also turned out badly, and Bough returned to Carlisle where he set himself up in a studio. His only formal training had been sketchy, given by a friend of the family before he had gone to work in the solicitor's office.

Although he was successful enough even at the beginning of his career, having had his first picture hung in the Royal Scottish Academy in 1844, he turned his back on full-time painting for a while, first becoming a scenic painter at the Theatre Royal, Manchester, before moving on again to Glasgow to become a scenic painter at the Theatre Royal. More moves followed before he finally settled in Edinburgh in 1855.

A highly talented artist whose merits were recognised in his own lifetime, he exhibited fifteen times at the RA between 1856 and 1876, and became a member of the RA in 1874.

One of his regrets as an artist was that his application to join the OWS was turned down for reasons which were not explained. Whatever his faults might have been that led to this, he remains a figure who had a great influence on Scottish watercolour painting.

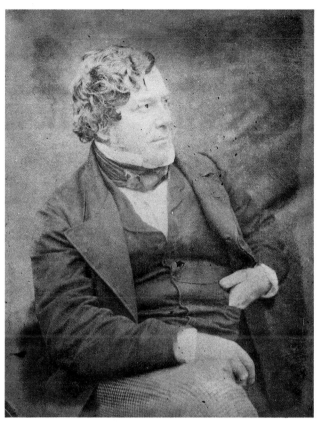

Charles Bentley (Jeremy Maas Collection)

WILLIAM ROXBY BEVERLEY
1811–89

The son of a family of northern actors whose real name was Roxby until the father added the name of Beverley for the somewhat odd reason that the family liked this small Humberside town, William was born in Richmond, Surrey. To begin with he channelled his talents into the field of scene painting and design which he did so successfully that he became the scenic director at Covent Garden from 1853 to 1884, while also painting scenery for the Drury Lane Theatre.

Despite the enormous pressures that were put on him by all this work, he still found time to pursue what was to become yet another successful career, this time as a marine and landscape artist, exhibiting twenty-five pictures at the RA from 1865 to 1880, all of them being coastal or fishing-boat scenes.

WILLIAM THOMAS NICHOLAS BOYCE
1858–1911

Boyce was born in Blakeney, Norfolk, the son of a ship master who moved his family to South Shields, Co. Durham, where he had acquired a number of collier brigs.

William's family originally intended him to become a

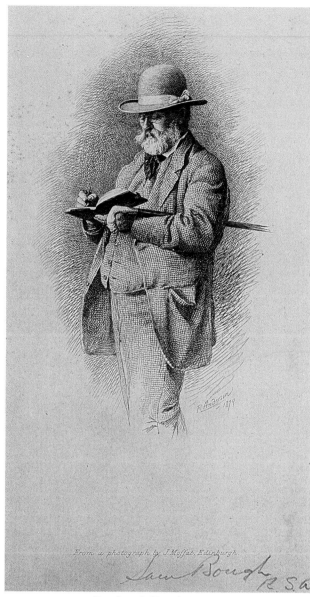

From a photograph by J. Moffat, Edinburgh.

Sam Bough (British Museum)

joiner, but after a few years' apprenticeship he went instead into a local drapery business where he stayed for many years. A keen amateur marine watercolour artist from his early youth, he began to turn more and more to painting, mostly along the north-east coast. He eventually became a well-known artist, but never exhibited in London.

He had thirteen children, two of whom were also to become marine watercolour artists.

J. F. BRANEGAN
fl. 1871–75

Branegan was almost certainly an Irishman whom we know was working in Dublin in 1841. He came over to the British Isles in his later years and visited many parts of Great Britain, including Norfolk as well as Scotland, before he settled in London at 118 Stanhope Street.

A marine watercolour artist who mostly painted coastal scenes, he exhibited at the RA from 1871 to 1875.

SIR OSWALD WALTERS BRIERLY, RWS
1817–94

Brierly was a distinguished watercolour artist who was at one time the official marine painter to Queen Victoria

After studying art at an academy in Bloomsbury, he went on to study naval achitecture at the naval college in Plymouth. He exhibited his first painting in 1839, and two years later was off on the first of his many travels, with the intention of sailing around the world. After visiting Australia he went on to New Zealand where he settled until 1851, when he returned home, only to find himself setting off yet again, this time accompanying the British Fleet to the Black Sea on the outbreak of the Crimean War in 1854.

On his return, Queen Victoria offered him the opportunity of sketching the great review of the Royal Fleet on its return from the Crimea. As a reward for his services to the country, he was made the Marine Painter in Ordinary to the Queen.

Now a favourite of the Royal Family, he found himself accompanying the Duke of Edinburgh to Norway and the Mediterranean, which was quickly followed by yet another trip around the world, again with the Duke of Edinburgh. He was undoubtedly the most travelled marine artist of the nineteenth century.

He was knighted in 1865, and spent the latter part of his life painting naval historical pictures, many of them of the Armada. In all, he exhibited more than two hundred paintings, most of them watercolours.

THOMAS BUTTERSWORTH
1768–1842

Born on the Isle of Wight, Thomas Buttersworth belongs to that small army of sailors who took up painting while at sea and eventually became so proficient in the art of marine painting that they were able to become professional artists.

Buttersworth joined the Royal Navy in 1775 when he was posted to a new frigate, the *Caroline*, where he was signed on as a humble able seaman. His progress was fast; by the latter part of the following year he was appointed a master-at-arms, and by 1800 he had become a midshipman. Nothing else is known about his brief naval career, which ended in the same year as he became a midshipman, when he was invalided out of the Navy at Minorca and sent home. However, he produced a number of watercolours of the Battle of St Vincent, which suggests he may have taken part in the battle.

HECTOR CAFFIERI, RI, RBA
1847–1932

Caffieri was born and educated in Cheltenham, but received his art training in Paris. Although his interests as a painter were wide ranging and included the painting of fruit and figure subjects, he also did a number of extremely effective marine watercolours of fisherfolk and their boats, which were painted in Boulogne, where he lived for some time. He exhibited at the RA from 1875 to 1900 and with the Société des Artistes Français from 1892 to 1893, where most of his watercolours were again marine subjects, such as his *Départ de Bateaux de Boulogne*. He is thought to have covered the Russo-Franco war of 1877 to 1888.

JOHN CALLOW, OWS
1822–78

Born in Greenwich, John was the younger brother of William Callow (1812–1908), a famous marine artist who taught his brother to paint. In 1835 John was taken to Paris by his brother, where he studied for several years.

On his return to England in 1844, he set himself up as a professional painter of landscapes. Later, he was to find his true *métier* as a marine artist.

In 1855 he took up a post as Professor of Drawing at the Military Academy in Addiscombe, Surrey, where he stayed for six years before taking on a new position as Sub-Professor of Drawing at the Military Academy at Woolwich, before he retired to teach and concentrate on his paintings.

He exhibited only three times at the RA, but exhibited yearly at the OWS, where 352 of his works were shown.

John Callow (Jeremy Maas Collection)

WILLIAM CALLOW RWS
1812–1908

A more than competent marine watercolourist for most of his life, William Callow was born in Greenwich, the son of a builder who encouraged his early efforts at painting by sending him to study art in Paris, where he was to

share a studio with the artist Thomas Shotter Boys (1803–74), a well-known High Victorian watercolour artist.

In 1834, Callow took over the studio from Boys and set up in business there as a teacher, drawing many of his pupils from the ranks of the French nobility. In 1841, he left Paris and settled in London, where he was to exhibit 1,152 pictures at the OWS before his death.

A painter of landscape and buildings as well as marine watercolours, Callow was a highly respected figure in his time, a man who had mingled freely with French royalty and who was on nodding terms with painters such as Constable and Turner. He lived to the great age of ninety-six, walking five miles or more every day until the year of his death in Great Missenden, Buckinghamshire.

GEORGE CHAMBERS, RWS
1803–40

The son of a humble Whitby sailor, Chambers was bundled out of the house at the age of eight to work on the coal sloops in the harbour, where he found himself the butt of thoughtless and cruel jokes from his fellow workers because he was so tiny, even for his age.

Nor did things improve when he went to sea at the age of twelve as an apprentice to the captain of the transport brig *Equity*, where the harsh treatment he received on board weakened his constitution and probably hastened his early death. In his rare leisure periods he sketched the passing vessels.

Thanks to the efforts of a Captain Braithwaite, who had met him and sensed that Chambers had some talent as an artist, the captain of the *Equity* released him from his indenture. Chambers then set himself up as a house and ship painter in Whitby, where he stayed for a while before deciding that his fortune lay in London.

Setting off there with only two pounds in his pocket, he was fortunate enough to find a benefactor in London. The landlord of the Waterman's Arms in Wapping took him under his wing and introduced him to some of the ships' officers who frequented his inn. A series of commissions to paint portraits of their ships followed, which led to his meeting with King George IV. From then on his future seemed assured.

Sadly, Chambers's period in the limelight was all too brief. He died in Brighton before he was forty, after making a cruise to Madeira in a futile attempt to regain his health. Turner and Sidney Cooper were among those who contributed to a fund to aid his destitute widow, and Clarkson Stanfield completed his last picture for him.

W. CHARLES
exh. 1870–71

A marine and landscape artist who lived in digs at 8 Old Jewry, London EC2, W. Charles seems to have exhibited only three watercolour pictures, all of them at the SS, though we know that he was still active as a painter three years later. Otherwise nothing is known about this artist. The three pictures he exhibited were *Mid-day-Brighton Beach*, *View near Luccombe Chine, Isle of Wight* and *The Beach — Hastings*. Although they were all exhibited at different dates they each fetched £6 6s. 0d., an average price in those days.

JOHN CONSTABLE, RA
1776–1837

Constable was born in East Bergholt, Suffolk, and educated at Dedham Grammar School. Even when he was young he was devoted to painting, which he studied in his spare time in the company of John Dunthorne, a local plumber and glazier, who also loved art.

His father, a wealthy miller, had intended that his son should enter the Church, but seeing that he was determined to become a painter he allowed him to visit London to consult the landscape artist John Farringdon, who recognised his talent and gave him a number of technical hints. He also made the acquaintance of the engraver J. T. Smith, who taught him etching.

In 1797 he entered his father's business, only to leave it two years later to enter the RA Schools. Apart from becoming an RA in 1829, his life seems to have been uneventful outside his struggles to become a successful artist. He lived the last years of his life in Hampstead, from where he continued to send contributions to the RA. Although he exhibited 104 pictures there in his lifetime, he never achieved any real popularity with the public.

EDWARD WILLIAM COOKE, RA
1811–80

Cooke was the son of George Cooke, a well-known engraver who had worked for Turner. Although he had no formal training at any of the academies, Cooke did receive lessons on how to paint and engrave from his father, who must have been an excellent teacher as his son began engraving botanical subjects for publication before he was nine. He was probably guided towards marine painting by his friend, Clarkson Stanfield, for whom he did a number of sketches of ships and their riggings in 1826.

In 1829 Cooke published his *Shipping and Craft*, now much sought after by collectors. He was then only eighteen. Six years later he began to exhibit at the RA, and continued to do so until the year before his death in Groombridge, near Tunbridge Wells.

John Constable (British Museum)

Edward William Cooke (Jeremy Maas Collection)

JOHN SELL COTMAN
1782–1842

Cotman was educated at the Norwich Grammar School, where his early talent for drawing was noticed and encouraged by the headmaster. After leaving school he worked for a while in his father's drapery business before setting off for London at the age of sixteen to learn to paint. He found work colouring aquatints for Ackerman, a print dealer at 101 The Strand, but became dissatisfied with the job within a year. The only good thing to have come from it all was his meeting with Dr Thomas Monro, a well-known patron of the arts who ran classes for aspiring artists who were allowed to copy from his own collection of important paintings.

Cotman returned to settle in Norwich in 1806, and stayed there until 1812, when he moved to Yarmouth to take up a post as a drawing master. In 1833 he became a Professor of Drawing at King's College, London, where he stayed for the rest of his life.

During the latter period of his life he hit upon the enterprising idea of setting up a Circulating Library of Art where students came to borrow drawings to copy.

However, the drawings were not done by Cotman, but by those members of his family who had a talent for drawing, including his son Miles Edmund (1810–58), who was also to become a marine artist.

ROBERT McGOWN COVENTRY, RSW
1855–1914

Coventry was one of the leading figures of the Glasgow artistic scene throughout his life. He studied at the Glasgow School of Art and then in Paris, before embarking on a career as a marine artist, and eventually becoming a member of the Blottesque School (see page 15). He worked mainly in Scotland, finding many of his subjects along the coast or among the western lochs. He also made a number of trips to Holland and Belgium, where he concentrated on painting market and fishing scenes. He began exhibiting at the RA in 1890. He is most known for his North Sea fishing scenes and Dutch harbours.

ERNEST DADE
fl. 1887–1904

A now well-known marine artist, Dade was born in Scarborough on 1 January 1868, the son of an obscure portrait painter. Like a number of other marine artists he went to sea at an early age, signing on as an ordinary seaman on the *Dauntless*, a famous American yacht of its time. Not finding the life much to his liking, he decided to take up art and went to study at the Académie Julian in Paris. From there he went on to study fresco and decorative painting in the South of France.

On his return to England he set up in business as a painter in Chelsea, where he lived from 1887 to 1888, before returning to Scarborough, where he painted coastal scenes along the Yorkshire and East Anglian shores.

A regular exhibitor at the RA from 1887 to 1901, he eventually returned to London where he was known to be still alive and living at an address in St John's Wood in 1929.

JOHN WOOD DEANE

Deane was an amateur watercolourist whose name is better known to us as the father of William Wood Deane (1825–73) and Dennis Wood Deane (fl. 1841–68), both of them known artists, especially William, whose Venetian scenes have been compared to those of Turner.

The father was actually the far more interesting character, a merchant seaman who had been present at the surrender of the Cape of Good Hope in 1803, and had later given up the sea and taken a job as a cashier at the Bank of England.

As he never seems to have exhibited or belonged to any of the painting societies, nothing else is known about him or his work except from the occasional marine painting which crops up in auction rooms and which is of a high enough quality for us to know that he was a talented artist.

CHARLES EDWARD DIXON, RI
1872–1934

Considered to be one of the finest marine artists of his period, Charles Dixon was the son of the genre and historical painter, Alfred Dixon (fl. 1864–91), and has the distinction of having had his first picture hung in the Royal Academy when he was only sixteen.

Although his true love lay with the sea, he served as a soldier rather than a sailor when he painted on his travels in South Africa, the Middle East and in North Africa. A large diary which he kept while in South Africa was considered to be of such historical value to the country that it was later acquired by her.

He was a superb painter of river, coastal and marine subjects, which were often done quickly and painted with great assurance.

A keen yachtsman throughout his working life, he was fortunate enough to have Sir Thomas Lipton as a friend, whom he accompanied on the five occasions when Lipton's *Shamrocks* participated in the America's Cup Races off Sandy Hook, which Dixon recorded.

WILLIAM CROXFORD EDWARDS
fl. 1872–1909

Edwards was a painter of landscape, coastal scenes and seascapes who has made life a little difficult for modern researchers by signing a number of his pictures W. E. Croxford.

He lived under both names in Brentford, Essex, and in Hastings and at Newquay, Cornwall. The date which he ceased exhibiting varies from one reference book to another, but the one given above is probably the most accurate, as one of his pictures of fishing boats at Yarmouth was sold in a London gallery in 1909.

He exhibited once at the RA in 1878 and a number of times at the SS between 1872 and 1876.

*he was WILLIAM EDWARD CROXFORD
1851 – 1926 as birth + census
record show*

ARTHUR HENRY ENOCK
fl. 1868–1910

A Birmingham artist, initially better known as a landscape painter, Enock produced a large number of marine paintings when he moved from Birmingham to Devon, where he became known as 'the artist of the Dart'.

A self-taught painter who began his career working for a Brazilian merchant in Birmingham, he studied for a while under David Cox, one of the most famous and best watercolourists of his time.

Enock first began exhibiting in a modest way in 1850, but did not become a full-time professional marine artist until he moved down to Devon, where he lived at various addresses, firstly in Dartmouth, before moving to Torquay and later to Newton Abbot, where he lived until his death in 1912.

ANTHONY VANDYKE COPLEY FIELDING
1787–1855

Although he was born in Halifax, Fielding spent his formative years in the Lake District. He studied watercolour painting under his father and then with John Varley, who had a considerable reputation as an art teacher as well as being a major watercolourist.

He began exhibiting at the RWS from 1810, and from then on he sent in between forty and fifty pictures for exhibition each year throughout his professional career. In 1831 he became its president.

In the 1820s he painted a large variety of marine watercolours, before settling on the south coast in Brighton, while still keeping a studio in London. Around 1847 he moved on to Worthing, where he stayed until his death.

JOHN FRASER, RBA
1858–1927

Fraser came from a seafaring family who lost two of their three sons at sea. John was more lucky as he went to sea in 1885 and spent the next twenty years travelling around the world, eventually returning to run a print shop in Grosvenor Road, Westminster.

It is not known where he received his art training, but it is obvious from his work that he was much more than just a competent marine artist by the time he began exhibiting in 1885 at the RA, where his work continued to be shown until 1919. He lived at various addresses in the London area, and was made an RBA in 1889.

SIDNEY GOODWIN
1867–1944

This marine watercolour artist lived in Southampton and is well known for his coastal and harbour scenes, many of them painted along the south coast and around Portsmouth and Southampton. He exhibited at the RHA.

He was the nephew of Albert Goodwin (1845–1932), a highly regarded painter in oils and watercolours, who was one of the first to use a pen line in combination with a watercolour wash.

CHARLES GREGORY
1810–96

Gregory was a marine artist who had an address at one time at 11 Marina Terrace, Cowes, on the Isle of Wight. He spent his whole life on the island, but obviously made frequent excursions to London at one time as a number of his paintings were exhibited in the London galleries between 1848 and 1854.

An exhibition of his work was held in Cowes in 1954, which was sponsored by a no longer existent firm of local shipbuilders, and was opened by the First Sea Lord and Admiral of the Fleet at the time, Sir Rhoderick R. McGrigor.

THOMAS BUSH HARDY, RBA
1842–97

Even someone who has only the slightest knowledge of marine art will have heard of this artist, whose work is now to be found in almost any picture gallery you might care to enter.

Born in Sheffield, he was an artist who travelled in France, Italy and Holland before he made any serious attempt to be hung in one of the major London galleries. His first set-back was when he made several attempts to become a member of the New Watercolour Society, only to be turned down each time. When he did become an RBA in 1884, he had to wait until he was in his early forties.

Yet in other areas he was successful enough. In 1871 he exhibited for the first time in the Royal Academy, and continued to exhibit there right up to the year before his death. In all, he exhibited thirty-two pictures there, mostly of the English, French and Dutch coasts, and a view of Venice. His favourite area, to which he returned several times to paint, was the Dutch fishing port of Scheveningen.

JAMES HARRIS JUNIOR
1847–1925

A Swansea artist, Harris was the son of James Harris (1810–87) who had also been a marine artist, as had his father before him. In his early years, Harris Jr. had been a seaman who had sailed around the Horn on the copper ore ship, the *Eta*, in 1867/68. He received his art training from the well-known London marine artist, Edward Duncan, who often went on sketching tours in the Bristol Channel and flourished in about 1865 until the late 1890s, and probably even much later.

EDWIN HAYES, RHA, RI
1820–1904

A Bristol man, Hayes's love of the sea led him to sign on as a member of the crew on a ship bound for America. On his return he went to live in Dublin, where he stayed for ten years before moving on to London in 1852.

Edwin Hayes (British Museum)

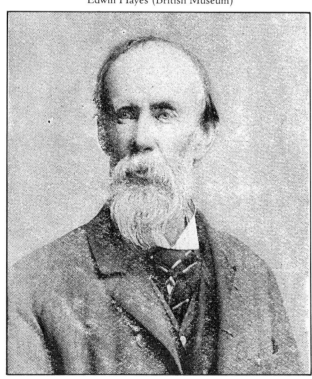

Dividing his time for a while between painting scenery for the Adelphi Theatre and pursuing his career as an artist, he was soon exhibiting regularly at the RA and at most of the major London galleries, where he rapidly established a small reputation for himself as a marine painter.

CHARLES NAPIER HEMY, RA, RWS
1841–1917

Unlike many nineteenth-century artists who seem to have led very uneventful lives, Hemy's was a rich and varied one. Born in Newcastle-upon-Tyne on 24 May 1841, he was the eldest of three brothers who all took up painting. In 1851 the family emigrated to Australia on the *Madawska*, on which his youngest brother was born while the ship was passing the coast of Brazil. When the family returned to England five years later he signed on as an apprentice on a merchant brig.

After his decision to abandon the priesthood (see page 16), he studied art first at the Newcastle School of Art, and then in Antwerp under a well-known historical and portrait painter. Why he chose to study there remains something of a mystery, as he was far more interested in marine painting, which he turned to almost exclusively in the 1860s. He first exhibited at the RA in 1868, and continued to do so regularly for many years.

In the 1880s he moved from London and lived in Falmouth, Cornwall until his death.

ALFRED HERBERT
c. 1820–61

Born in Southend, the son of a Thames waterman, Herbert gained much of his knowledge of ships from being apprenticed by his father to a ship builder.

He began exhibiting at the RA from 1847 and continued to exhibit there until the year before his death. These paintings were of fishing vessels and beach scenes in Brittany and Holland, and a few that were painted on the Thames estuary. Because his life was a relatively short one, the number of his paintings shown in the London galleries was small, amounting to a mere forty-three pictures.

Charles Napier Hemy, portrait painted by Mons Legros 1870 (British Museum)

GEORGE HOWSE, NWS
exh. 1830; d.1861

In his relatively brief exhibiting career, Howse painted a variety of subjects, ranging from the doorways of various churches around Shrewsbury, to landscape and coastal scenes at home and abroad. A London artist who was living at 1 Montague Close, Southwark when he began exhibiting, he was a prolific painter who had twenty-six of his paintings exhibited at the RA and an impressive total of fifty-three paintings shown at the NWS. He was one of the many nineteenth-century artists of whom much is known about his work, but virtually nothing of the man himself.

WILLIAM JOY JOHN CANTILOE JOY
1803–67 1806–66

A number of artists have worked together as a painting team, but none so constantly or as successfully as did the brothers William and John Cantiloe Joy, who started off their lives on the Isle of Wight.

Soon after they had embarked on their careers as marine painters they were befriended by a wealthy patron of the arts, Captain Charles Manby, who made it possible for them to use a room in the Royal Hospital, Yarmouth as a studio, while at the same time encouraging them to go to his home, where they were allowed to copy some of the paintings from his own fine collection. Manby was an interesting character in his own right, having invented an apparatus for firing a rope by mortar to a ship in distress, which was first used in 1808.

Around 1832/33, the brothers moved to Portsmouth, where they worked for the Government as draughtsmen. By then, their reputation as marine artists had been firmly established. William had exhibited at the RA in 1824 and 1832, and John exhibited regularly at the SS Galleries between 1826 and 1827.

ALBERT ERNEST MARKES
1865–1901

The son of marine artist Richmond Markes, who lived and painted in Newquay, Cornwall, Albert began his working life as a shop assistant in Newquay before moving to London, where he found a ready market for his paintings of coastal scenes and fishing boats. Because of his addiction to drink he was often exploited by dealers, though others helped to keep him gainfully employed by sending him to paint in Leigh-on-Sea and Southend, and then to Holland and Belgium, from where he returned with a large number of lively paintings of their coasts and waterways. He always signed his pictures 'Albert'.

PAUL MARNY
1829–1914

Born in Paris, Marny was a landscape and marine watercolour artist who lived and worked for some years in France before going to Belfast, where he was employed for a short while by a fellow countryman who had set up in business there as an architect. In 1860 he moved to Scarborough, where he was to spend the rest of his life except for the few occasions he revisited France on holiday.

As an artist he was not very successful until 1860, when he was fortunate enough to meet an art dealer named John Linn, who offered to take all Marny's output for a weekly payment of five pounds. This is not such a bad deal as it might seem, as many pictures by quite competent artists fetched only ten pounds in auction.

WALTER WILLIAM MAY, RI
1831–96

A London-born marine artist who painted in oil and watercolour, May served in the Navy from 1850 to 1870, retiring with the rank of captain.

He began painting around 1859, and from all accounts his career as an artist was a very successful one as he had exhibited 344 pictures, five of them at the RA, before his death.

He painted coastal subjects as far apart as England, France, Holland, Norway and Venice. In addition, he also found time to illustrate a number of books, as well as publishing his own on marine painting in 1888.

WILLIAM FREDERICK MITCHELL
1845–1914

An artist who worked mostly in watercolours, Mitchell painted more than 3,500 ship portraits, either commissioned or done for his own pleasure. In addition, he painted some of the old-time vessels such as *The Great Harry* and *The Royal George*, which were produced as coloured lithographs in 1870, and have now become highly regarded collectors' items. Not content with all this work, he also drew illustrations for Brassey's *The Naval Annual,* and published a book, *The British Navy, Past and Present*, in 1905.

He died in Ryde, Isle of Wight, not, as one might think, a rich man, as a great number of his commissions were painted for young naval officers for only a few shillings.

JOHN MOGFORD, RI
1821–85

A watercolourist of some standing in his lifetime, Mogford came from a Devonshire family, but was born in London. He received his training at the Government School of Design at Somerset, and later married the daughter of Francis Danby, a well-known painter who specialised in painting romantic and quasi-religious subjects.

An industrious painter, Mogford exhibited 392 pictures at the London Galleries, including thirty-three pictures at the RA between 1846 and 1881, many of them English coastal scenes and seascapes.

GEORGE NATTRESS
exh. 1866–88

In the twenty-two years he exhibited, George Nattress turned his hand to painting a large variety of watercolour subjects, including landscapes, studies of flowers, various buildings and marine subjects. A London-based artist who exhibited twenty-two pictures at the RA and a number of others elsewhere, he belongs to the vast army of still sparsely recorded painters, despite the enormous amount of research that has already been done on the artists of the nineteenth century.

FRANCES E. NESBITT
1864–1934

Frances Nesbitt has been recorded as having been a landscape and genre painter, but in fact she also painted quite a number of marine subjects, such as *Bringing in the Sprats, Lowestoft, Waiting for the Tide*, and harbour scenes at Concarneau and Whitby, as well as painting various fishing scenes off Venice.

She lived at 8 St Albans Road, Kensington, and also had a studio flat at 7 Elm Tree Road, St John's Wood, before moving on to addresses in Lincolnshire and Devon, and retiring in 1926 to Hertfordshire. She exhibited at most of the important London galleries from 1888.

RICHARD HENRY NIBBS
1816–93

Nibbs started off his working life as a professional musician who taught the violin and cello and was later a member of the Theatre Royal orchestra in Brighton. An unexpected inheritance made it possible for him to go into the precarious business of earning his living by painting, which he did with a fair degree of success, exhibiting forty-two times at the RA, and also at the BI and SS. His name is always associated with Brighton, but he was actually a Londoner who spent much of his time in Brighton, where he kept a studio at 52 Regent Street. In 1841 he made this famous seaside town his permanent home, where he began living at 11 Zion Place.

A self-taught artist who painted a large number of attractive marine watercolours, the quality of his work was not fully appreciated until recent years.

ARTHUR WILDE PARSONS, RWA
1854–1931

A Bristol marine artist who was the son of a doctor and who studied locally, Parsons was well known for the large number of paintings he did of ships and scenes along the shores of the Bristol Channel. These were followed later by a number of coastal scenes in Cornwall, painted while on holiday there at the home of his brother, the Vicar of Crantock. He exhibited eighteen pictures between 1867 and 1904, some of them painted in Italy, a country which seems to have had a great influence on his work. As with most marine artists who visited Italy, Venice held a special attraction for him.

NICHOLAS POCOCK, OWS
1741–1821

Pocock belonged to the period when Britain's Navy was at the height of her powers, with a string of successful battle achievements behind her during the Napoleonic wars and after that had made her the most feared and respected of all maritime powers. As an artist who had lived long enough to record most of the battles of the eighteenth and early nineteenth centuries, he has become one of the favourite painters of maritime historians.

The son of a prosperous Bristol merchant, he went to sea at an early age, and by 1767 was in command of the *Lloyd*, a merchantman that traded with America. By then he was already toying with the idea of abandoning the sea in favour of a career as a marine painter. Any lingering doubts he had were dispelled after he had submitted a painting to the Royal Academy and had received an encouraging letter from its President, Sir Joshua Reynolds. He began exhibiting at the RA in 1782, and within a few years had established himself as one of the best marine artists of his day. In 1804 he became one of the founder members of the OWS.

THOMAS SEWELL ROBINS
c.1809–80

A coastal and marine painter who lived in London, Robins received his training at the Royal Academy Schools, where he was fortunate enough to have the great J. M. W. Turner as his lecturer on perspective. Primarily a watercolour artist, Robins not only ranged far and wide around the English coast for his subject matter, finding it in such widely diverse places as Margate, the Isle of Sheppey, Littlehampton and the Mumbles in South Wales, but also made a number of excursions over to Holland to paint scenes of the Dutch coast.

In 1839 he was elected an Associate of the NWS, where he exhibited 317 works. He also exhibited six pictures at the RA, and a number at various other important galleries.

FRANK W. SCARBOROUGH
fl.1890–1939

Scarborough came late on the scene of maritime painting but was still in time to make a valuable contribution to its history during the closing decades of the nineteenth century. He specialised in painting scenes of shipping in the Pool of London in a style that is immediately recognisable. He exhibited with the RBSA and the Glasgow Institute of Fine Arts.

He lived in London for some time before moving to Lincolnshire.

CLARKSON STANFIELD
1793–1867

Stanfield was born in Sunderland, the son of a sailor who had been engaged in the slave trade until he became so disgusted with it that he gave up the sea and joined a theatrical company for a while, and then went on to make something of a name for himself as a writer on behalf of the abolitionists. His son entered the merchant navy in 1808 and made several voyages before being pressed into the Royal Navy as a clerk, a not too unhappy period in his life as he began painting the scenery for the modest stage productions held on board ship.

In 1818 he left the navy and embarked on a career as a scene painter for a number of small theatres which culminated in his obtaining the plum job of the scene painter for the Drury Lane Theatre, where he worked for twelve years, gradually establishing for himself a reputation for being the best theatrical scene painter of his age.

In the meantime, Stanfield had also established himself as a marine artist with such success that he was exhibiting at the RA by 1820.

His energy was enormous. Besides holding down a job at Drury Lane, he painted his pictures at a furious rate, contributing 135 to the RA as well as producing all those sold outside the exhibitions. He also did a number of engravings and illustrations for books, while still finding time to travel and lead a busy social life.

Clarkson Stanfield (Jeremy Maas Collection)

CHARLES TAYLOR JUNIOR
fl. 1841–83

The offspring of Charles Taylor Senior (fl. 1836–71), who also specialised in marine painting, the son's marine pictures were all done in watercolours, many of them of Thames tidal and estuary scenes. He exhibited for a short while at the RA between 1846 and 1849, but the main body of his work was shown at the RI between 1843 and 1866.

He was a London artist who lived for a period at Scarsdale Terrace, Kensington, before moving on to 3 Gloucester Place, Camden Town.

RALPH TODD
1856–1932

If it had not been for his decision to leave London and settle in Newlyn, Cornwall, Todd might have remained nothing more than a small entry in the reference books as a genre artist who had exhibited three times at the RA. He arrived there in 1883 and became involved with the Newlyn School of Painters and, as a result, came to be a well-known artist who specialised in painting local fisher-folk. Later, he moved to Helston, Cornwall, where he continued to paint until 1928.

HENRY SCOTT TUKE, RA, RWS
1858–1929

Born in York, Tuke came from a staunch Quaker family that included a number of distinguished physicians who all specialised in the treatment of the insane. He studied art at the Slade School in London and then continued his studies in Italy and Paris, where he joined the atelier of Jean Paul Laurens, a well-known historical painter with an excellent reputation as a teacher. In 1883 he took a studio for himself at Passy, a residential area of Paris, where he was to meet the famous portrait painter John Singer Sargent, whom he found 'too polished and suave for his liking', and Oscar Wilde.

Although he soon became known as an excellent marine watercolour artist, his career did not reach its peak until 1889, when his painting *All Hands at the Pump* was shown at the RA, six years after he had joined the famous Newlyn School of Painters in Cornwall. Later he was to break away from them and settle near Falmouth, where he stayed until his death.

JOSEPH MALLORD WILLIAM TURNER, RA
1775–1851

Turner was born in London, the son of a barber who kept a shop at 26 Maiden Lane. His mother, Mary Turner, was said to have an uncontrollable temper and went insane towards the latter part of her life. In the circumstances it is not surprising that Turner's childhood was an unhappy one, and may well have accounted for his being unsociable and eccentric when he grew up.

His painting career could be said to have begun in the late 1780s, when he began selling his paintings from the front window of his father's shop. It was about this time also that he started to have lessons from Paul Sandby (1725–1809), who has been called 'the father of English watercolours', which frankly is to give him more than his due.

In 1789 he became a student at the Royal Academy Schools. He also worked for a short time in the house of Joshua Reynolds, probably with the intention of becoming a portrait painter himself. If this indeed were the case, nothing came of it as Reynolds died soon afterwards.

Until 1792, Turner confined himself almost entirely to watercolours, from which he turned away for some years. When he returned to painting watercolours, his talents in this medium were to make him more famous than ever, particularly in the field of marine painting.

He exhibited at the RA until 1850, though by then his powers had begun to wane. His sight and mind began to fail, and from then onwards his story is a pathetic one of a great artist struggling to continue working although his talent was steadily ebbing away.

By then he had given up all his old trappings of wealth, such as trips to the continent, a town house, and a country home in Twickenham, a boat on the river and a gig which he had used to take him on his sketching expeditions. Instead, he now lived as a lodger in Chelsea, overlooking the river, driven by his desire to be away from the public gaze. When he died, his reputation had finally been established, and he was buried in St Paul's Cathedral.

His pictures were left to the nation, over three hundred oils and nearly twenty thousand drawings. His fortune of £140,000, a considerable sum in those days, was left to found a charity for the 'maintenance of male decayed artists who were born in England and of English parents only, and of lawful issue'.

GEORGE STANFIELD WALTERS, RBA
1838–1924

Born in Liverpool, the son of Samuel Walters (1811–82), an accomplished marine painter himself, George Stanfield Walters followed a family tradition of sea painting which had begun with his grandfather Miles Walters (1774–1849), who started painting marine subjects after he had established a framing, carving and gilding business in Liverpool.

Leaving the family business, Walters went to London in 1865, where he lived for a while at Haverstock Hill. By then he had already exhibited his first picture at the RA in 1860, and was to continue exhibiting there every year until his death.

Wealth on a Flowing Tide, was bought by the Chantrey Bequest and left in trust to the Royal Academy by the well-known sculptor St Francis Legatt Chantrey, for the acquisition of 'works of fine art of the highest merit . . . that can be obtained.'

In 1906 he bought the Tower House in Portsmouth, and many of his works were painted from this vantage point, overlooking the harbour. A great number of these were watercolours, which remained his favourite medium to the last.

RICHARD HENRY WRIGHT
1857–1930

A large number of landscape artists turned their hand from time to time to painting marine subjects with varying degrees of success, including Richard Henry Wright, who also specialised in architectural studies.

A London artist who married the well-known still-life, flower and genre painter, Catherine M. Wood (exh. 1880–1939), Wright exhibited at all the major galleries and the RA from 1885 until 1913. He travelled widely in Switzerland, Italy, Greece and Egypt, painting many of the local views.

WILLIAM LIONEL WYLLIE, RA, RI
1851–1931

A highly prolific painter and etcher who was equally at home working in oils or watercolours, Wyllie was the son of the genre artist William Morrison Wyllie (fl.1852–90). After spending much of his childhood being shuttled between England and France, where the family had a summer home in the coastal town of Wimeraux, near Boulogne, he was sent to Heatherley's Art School, from where he went on to the Royal Academy Schools which he joined in 1865.

His professional career began three years later when he exhibited his first picture at the Royal Academy. From then on he became a regular exhibitor at all the major London galleries. His steadily growing reputation as a marine artist was firmly established in 1883, when his famous picture of barges and tugs, *Toil, Glitter, Grime and*

THE PLATES

NOTE: Although all the other artists in this colour section are in strict alphabetical order, it was thought only right that John Thomas Serres should be the exception, and placed first as a major representative of the Dutch School of Painting, which brought about the birth of maritime painting in England. In this position, it also provides an easy reference for those who wish to compare a typical marine watercolour of Serres's period with that of the work of some of the English artists who followed him.

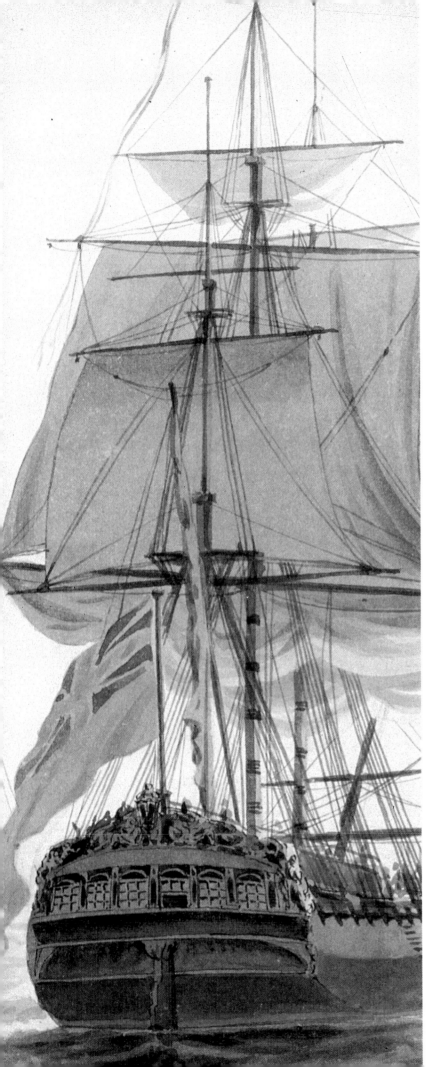

John Thomas Serres
1759–1825

A number of maritime artists who had come directly under the influence of the Dutch School of painting spanned the eighteenth and nineteenth centuries in their lifetime. One of these artists was John Thomas Serres, the elder son of Dominic Serres the Elder, who had been marine artist to George III.

On the death of his father in 1793 John took over his father's post, and seven years later was also appointed marine artist to the Admiralty, a position which called on him to sail on one of his majesty's vessels along the English coast and those of France and Spain, while making drawings which would provide a valuable guide for future sailors looking for landfalls. A number of the drawings he produced on these trips for the Admiralty were later published in a book called *The Little Sea Torch*.

He also taught drawing for a while at the Chelsea Naval School, which led to his publishing *Liber Nauticus*, a handbook which he had produced to help his students identify different types of vessels.

When he decided to take time off from his duties in order to make an extended tour of the Continent, everything seemed to indicate that Serres was set on a course for a well-ordered, successful and happy life. And so it might well have been if he had not made the fatal mistake of marrying on his return to England a woman named Olivia Wilmot, the daughter of a housepainter, and one of his pupils who had gone on to become an artist and writer. From then onwards his domestic and social life became a nightmare downhill path which was to lead him inexorably to a squalid death in a debtors' prison.

His wife, he found out somewhat late in the day, was an immoral and recklessly extravagant woman who ran up bills everywhere and plunged him quickly into debt. For good measure she became unhinged after she had been appointed landscape painter to the Prince of Wales, a post which seems to have gone to her head as she then became convinced, for no explicable reason, that she was the illegitimate daughter of the Duke of Cumberland.

Hounded by his wife's creditors and ostracised by society because of his wife's outrageous behaviour, which had included having two illegitimate children outside her marriage, Serres finally could stand it no more. In 1804 he divorced her and fled to Edinburgh, hoping to find some peace and quiet there. Instead, no sooner had he settled in the city than he learned that his ex-wife had taken advantage of his absence from London by selling all his paintings and pocketing the money. He had hardly recovered from the shock when her creditors caught up with him and he was flung into prison, where he made an abortive attempt to commit suicide.

He eventually returned to London where he continued to exhibit at the RA. In a desperate attempt to please George III, with whom he was now distinctly out of favour, he painted four pictures of the King's visit to Scotland in 1822. It made no difference. All his attempts to communicate with the Court were ignored and the four pictures which he had hoped would restore him to favour had to be put in auction where they were sold for the knock-down price of twenty pounds.

Still pursued by creditors, and now rejected by everyone, the future for Serres seemed bleak. But the worst was still to come. He began to develop a tumour on his left side and soon afterwards became seriously ill. In 1825 he was committed to prison for debt just before Christmas, where he died on 28 December. His wife, who had tormented him for all those years and had been entirely responsible for his downfall, was also to die in a debtors' prison, in 1834, leaving behind her a daughter by Serres, who continued to pursue her mother's absurd claims.

The life stories of some of the nineteenth-century artists can make harrowing reading. But one would be hard put to find anything quite so appalling as the story of John Thomas Serres.

He was not a great marine watercolour artist as his father had been; it is doubtful, in fact, that he would have been appointed marine painter to George III if his father had not held the post before him. But his work was always more than competent and could sometimes reach unexpected heights. The watercolour *HMS* Sirius, opposite, is a typical example of his painting.

John Thomas Serres, *HMS* Sirius. 12¼in x 18¼in, Bonhams.

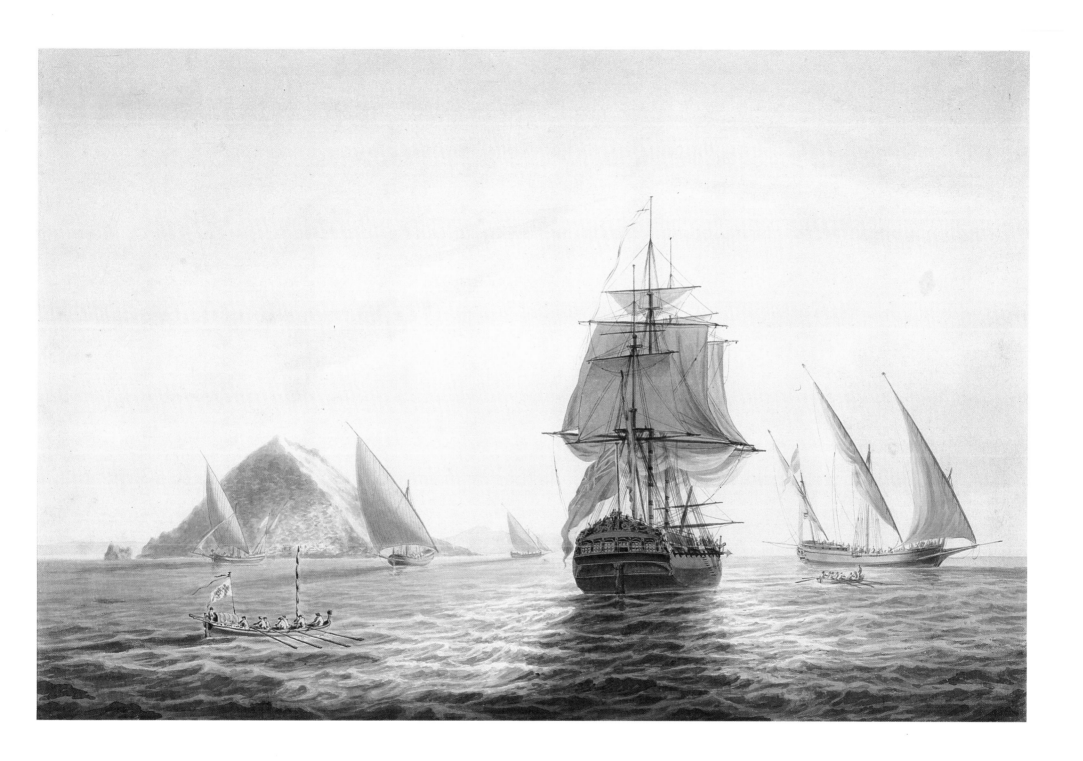

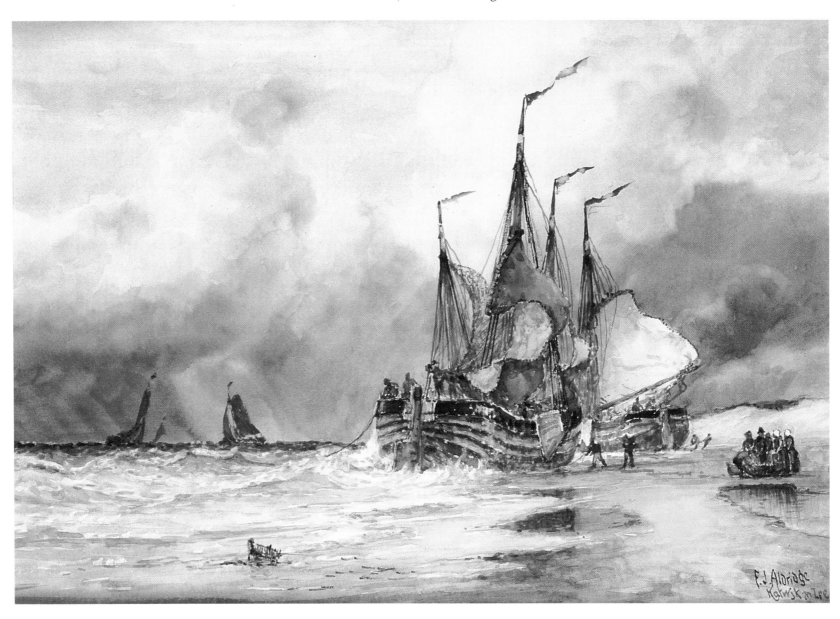

Considered at one time to be little more than a run-of-the-mill maritime artist, Aldridge's work has now begun to be appreciated by discerning dealers for its distinctive colouring and the high quality of painting, especially when Aldridge was dealing with foreign vessels and the way the sea flowed and ebbed along a shore line. A typical example is the Dutch scene on this page.

Aldridge was particularly drawn to the Dutch coastline, with its picturesque harbours and bustling quays, where the colourful costumes of the local fisherfolk and their unusual vessels had already proved an irresistible attraction to many other artists of the period. No doubt the alien rigging of so many of the boats also presented something of a challenge to all of them.

Although he painted well into the twentieth century, much of his work remained firmly rooted in the traditions of the latter-day nineteenth-century maritime art, when muted colours were used — in direct contrast to the colouring of so many twentieth-century artists who seem to favour strong colours. This is particularly evident in the colour of the sea, when a strong blue is favoured, occasionally giving the painting a slightly garish look, more in keeping with the cover of a chocolate box, rather than a work of art.

Aldridge painted in a very loose style in which various shades of browns and yellow-greens were often the predominant colours. But the style is deceptive as it tends to conceal from all but a perceptive eye the care taken over some of the small details in the watercolour opposite, such as with the pools of reflective water left behind on the beach, and the way the spume breaks on the prow of the fishing vessel. The rain-bearing clouds coming in over the sea add a touch of drama, and make an effective backcloth to the whole picture.

The figure work is interesting. Although only indicated with blobs of watercolour, they are still recognisable as people, especially the men on or around the boat, whom Aldridge has indicated with a mere dab or flick of the brush, while still making it quite clear what they are about. All in all, a marine watercolour that makes a welcome contrast to many of the overworked paintings that are around.

F. J. Aldridge, *Katwijk-aan-Zee*. 10in x 14in, Fine-Lines (Fine Art).

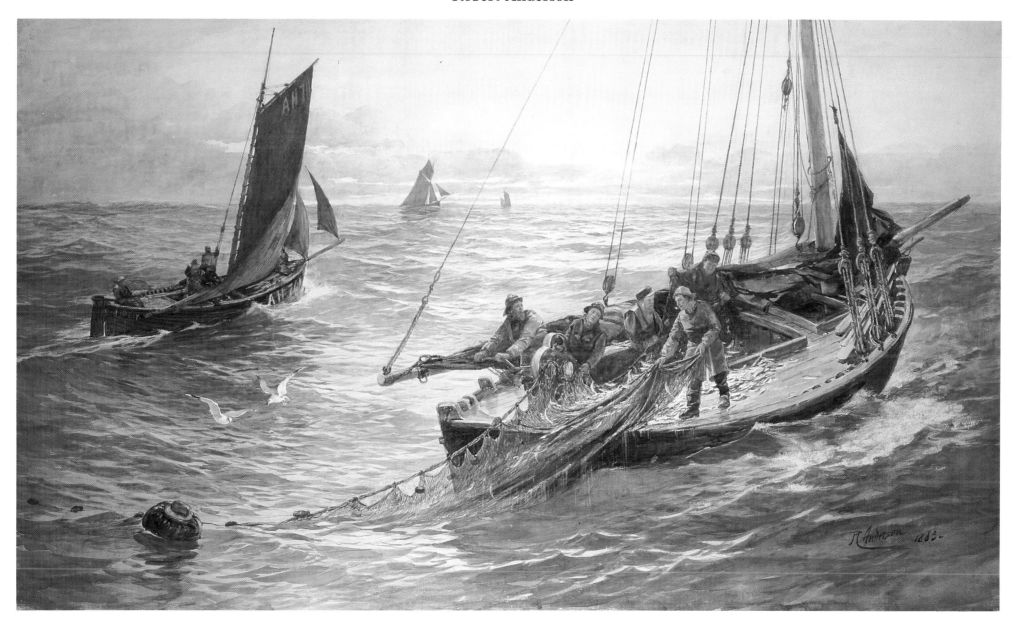

Robert Anderson, *The Herring Fleet*, 1883. 31in x 52in, David James.

As Scotland has a coastline of exceptional variety and beauty, with fishing as one of her major industries, it is hardly surprising that she has produced a large number of exceptionally talented marine artists, some of whose names have become legendary. Although Robert Anderson was never in the major league alongside artists like McTaggart or Sam Bough, it is still inexplicable that his work has never been given the attention it deserves, as many of his watercolours of fishermen engaged in their lonely and often hazardous calling are exceptionally fine examples of marine painting. If any fault can be found with his work, it is the way his training as an engraver sometimes betrayed him into being a little too precise, with an overuse of the engraver's hard line when a soft one would have been more pleasing.

This does not apply, however, to his watercolour *The Herring Fleet*, shown on the right, where we see Anderson at his best. Painted in 1883, only two years before his death, it was one of the many powerful and very large subjects which he painted during the last six years of his life when he turned entirely to watercolours.

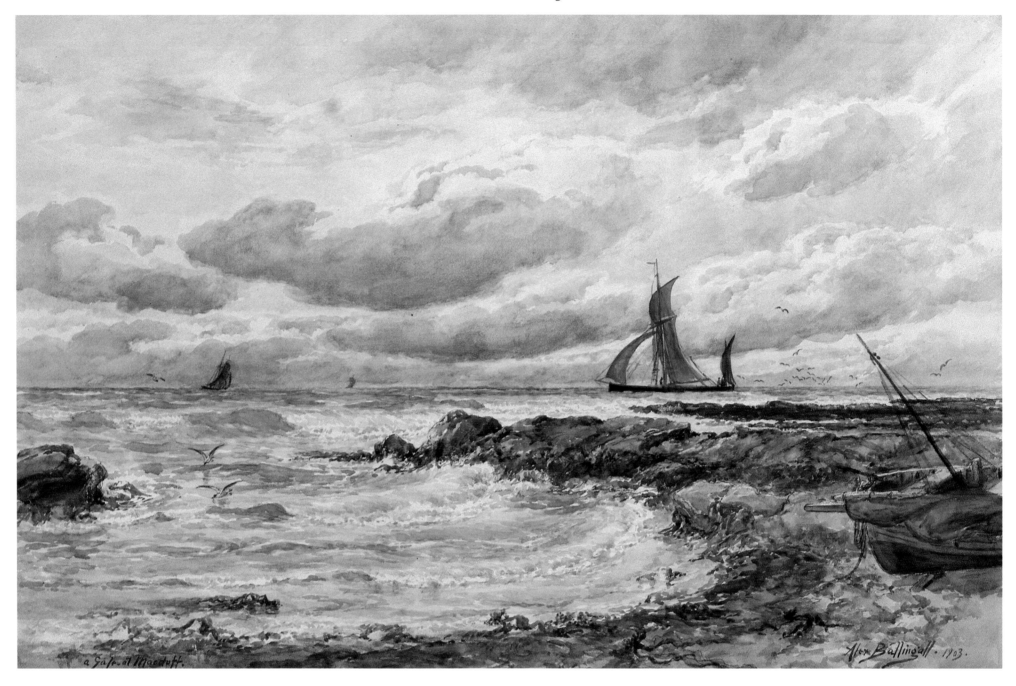

Once the Scottish artists Sam Bough and William McTaggart had shown the value of painting marine subjects on the spot, many other local artists were quick to follow their example. The idea of *plein air* painting was to become commonplace enough, and would not have deserved any special mention if it had not had a particular effect on Scottish marine painting. Because the weather around their coastline was less kind than that encountered around England, much of the Scottish marine painting from that time onwards was liable to be painted under bad weather conditions, often showing some sailing vessel being buffeted about by a strong wind under a leaden sky. Sunlit paintings like Tuke's watercolour on page 89 are something of a rarity in Scottish marine painting.

Alexander Ballingall's painting *A Gale at McDuff*, shown on this page, is a typical example of this sort of watercolour. His fishing vessel is obviously not in any sort of difficulty, but the day is clearly an unpleasant one, with the gulls beginning to head in from the sea — a sure sign of wet and windy weather, with more to come. It is the sort of day when many artists would have made a few sketches and then taken them away to finish off painting at leisure in their own home.

Ballingall was not a major watercolour artist. But he could lay down a scene exactly as it was when he painted it — something that more important artists have not always succeeded in doing.

Alexander Ballingall, *A Gale at McDuff*, 19in x 29in, Fine-Lines (Fine Art).

Charles Bentley

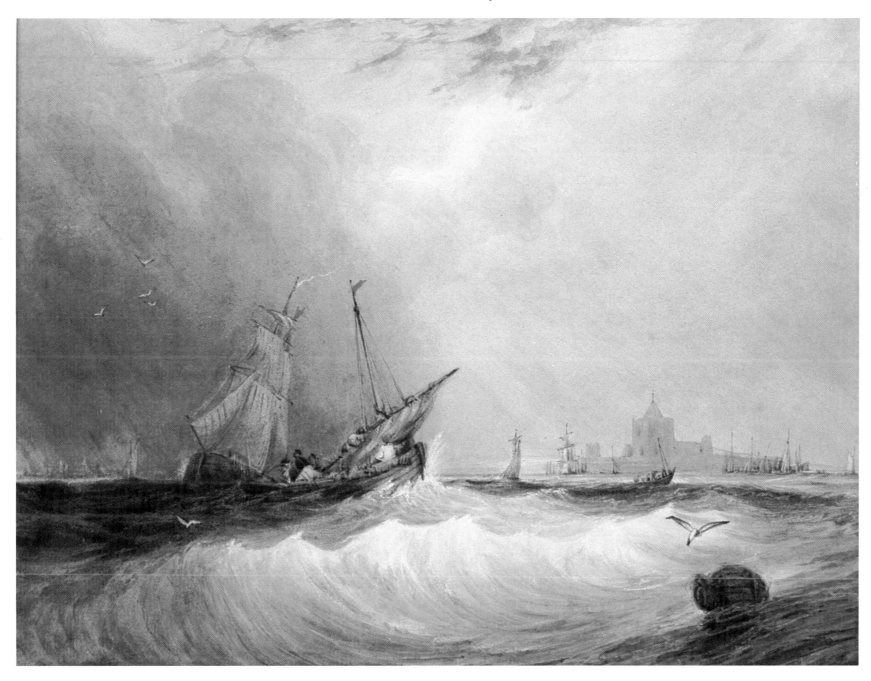

The watercolour above is truly representative of the work of Charles Bentley, whose name is very well known to art dealers, and always receives a mention in most of the reference books on maritime art. He was an artist who roamed far and wide in his search for marine subjects to paint, which ranged from English coastal and river scenes to others abroad in places as far apart as Normandy and the Far East. A life-long friend of William Callow, who accompanied him on a number of his trips, Bentley seems to have spent a great deal of his life travelling, making a tour of the coast of Ireland on one trip, and then going off on another to Venice. As he was always short of cash one cannot help wondering where the money came from to finance these excursions.

His work is always spirited and tremendously assured, though sometimes a little coarse in certain areas, as with his treatment of the waves in his untitled picture here. It is a painting which has enough activity in it to satisfy the marine water-colour collector, who likes to see something more than a ship going majestically by in full sail. Here you have a small fishing vessel riding the waves, at least a dozen other vessels in the vicinity, with dramatic storm clouds gathering, swooping gulls and a distant fort thrown in for good measure. Like most of the Victorian painters, Bentley believed in giving good value for money.

Examples of his work can be found in the Victoria and Albert Museum, the Leeds City Art Gallery and the Newport Art Gallery.

Charles Bentley, untitled watercolour. 8½in x 11½in, Fine Art, Petworth.

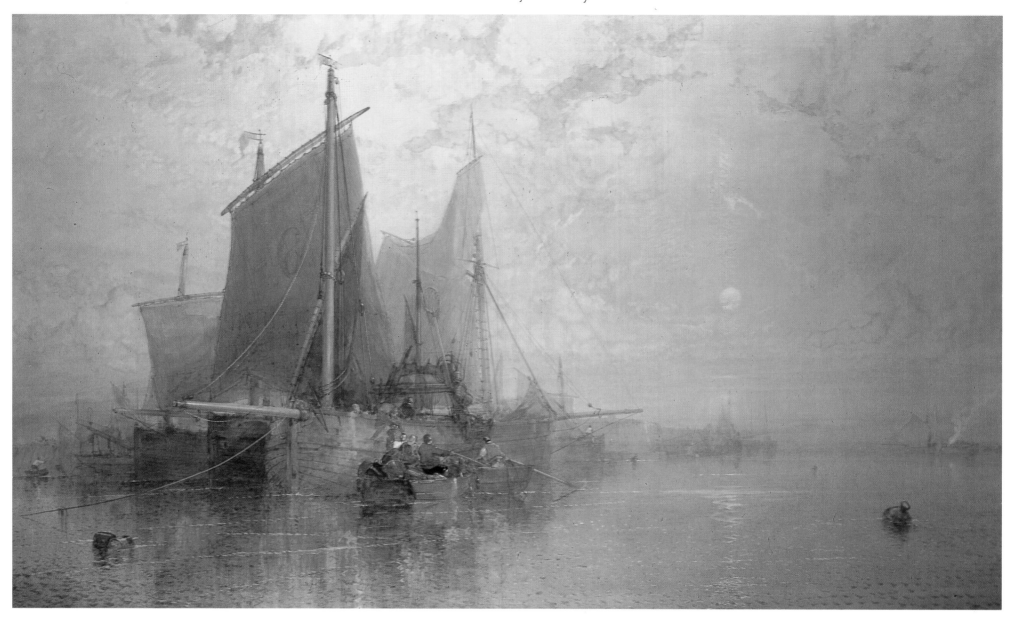

William Roxby Beverley, *Fishing Boats – Early Morning*, 1866.
30¼in x 51¼in, Brian Sinfield.

Beverley occupies a rather odd position in the history of marine watercolour painting, inasmuch as he always had a foot in two camps, one in the theatre as an important scene painter and set designer, and the other in the field of art, where his work now generally receives a respectful nod in most of the reference books on the subject. Otherwise, his work is almost unknown to the general public, a fact acknowledged by Martin Hardie in his *Watercolour Painting in Britain*, when he made a point of commenting that if there had been a wider knowledge of Beverley's work he would have held a higher place than he does in the history of watercolours.

Certainly, on the evidence of his watercolour here alone, Beverley was an important marine artist whose work is full of subtle details not obvious to the layman at a casual glance.

The main body of the picture is ranged well to the left, leaving a large area of water, which has obviously been done deliberately to allow Beverley the opportunity to paint an expanse of limpid waters – something of a trade mark in many of his watercolours. The early morning sun which catches some of the tiny ripples on the sea adds enormously to the atmosphere and emphasises the tranquillity of the waters which recede into the distance, where other moored vessels begin to emerge from the early morning mists.

In contrast to the stillness of the waters and the general feeling that the day's work has not yet begun on the other boats, the main vessel is full of activity as some of the crew prepare to go ashore. Again, in direct contrast to the soft golden glow on the water, the vessel is strongly painted and in some detail.

Sam Bough

Sam Bough owed a great deal to David Cox's influence on his landscape painting, but he owed even more to Turner for his marine watercolours which were brilliant essays in colour, very much in the manner of some of the master's work in the way that light and form dissolved and merged with the vigorous application of clear colours. R. L. Stevenson said of Bough that when he painted it was like 'an act of dashing conduct like the capture of a fort in war'. The simile may be a little strained, but one can see what Stevenson meant.

Bough tended to be a dramatic marine watercolour artist, not so much in his choice of subject matter, but rather in the way that he used his colours. One has only to look at his gouache here. The subject is quiet enough, but the picture has a brooding intensity about it more commonly seen in an oil than a watercolour because Bough used dark, sombre colours which he laid on more heavily than in most of his watercolours. Dramatically speaking it has much more in common with the sort of nineteenth-century illustration you might find in *Great Expectations* when Magwich is captured trying to make his escape from England. The real difference, of course, is that the gouache is obviously the work of a superb artist, rather than something drawn by a conventional illustrator.

Although Bough did a great deal of landscape painting during the early part of his professional career, he turned entirely to marine painting from the 1850s after his interest had been caught by marine architecture and the study of ships and boats and their rigging. From then on he was a regular visitor to the east coast, where his figure sitting at his easel under a multi-coloured umbrella soon became a familiar sight to the villagers at Anstruther and St Monance. When he was not engaged in painting the shipping in the harbours, he would prevail on one of the fishermen to take him out in their boat in order that he might sketch at sea. Sometimes he would concentrate on nothing more than light on water with cloud effects; on other occasions he would work up a fairly elaborate watercolour, containing a great deal of detail, and always enhanced by subtle colours and lighting effects.

As the years went by his work became more bold and assured. Something of his old subtle use of colour was lost in the process, though many consider that his later years were when his powers were at their greatest. Certainly, his watercolours remained full of vitality, superbly designed and impressive to look at. Perhaps one should not ask for more.

Examples of his work can be seen at the Scottish National Gallery, Edinburgh, the City Art Gallery, Dundee, and the National Maritime Museum, Greenwich.

Sam Bough, *The Dreadnought from Greenwich Stairs – Sun Sinking into Vapour*. Gouache, 35¼in x 20¾in, Moss Galleries.

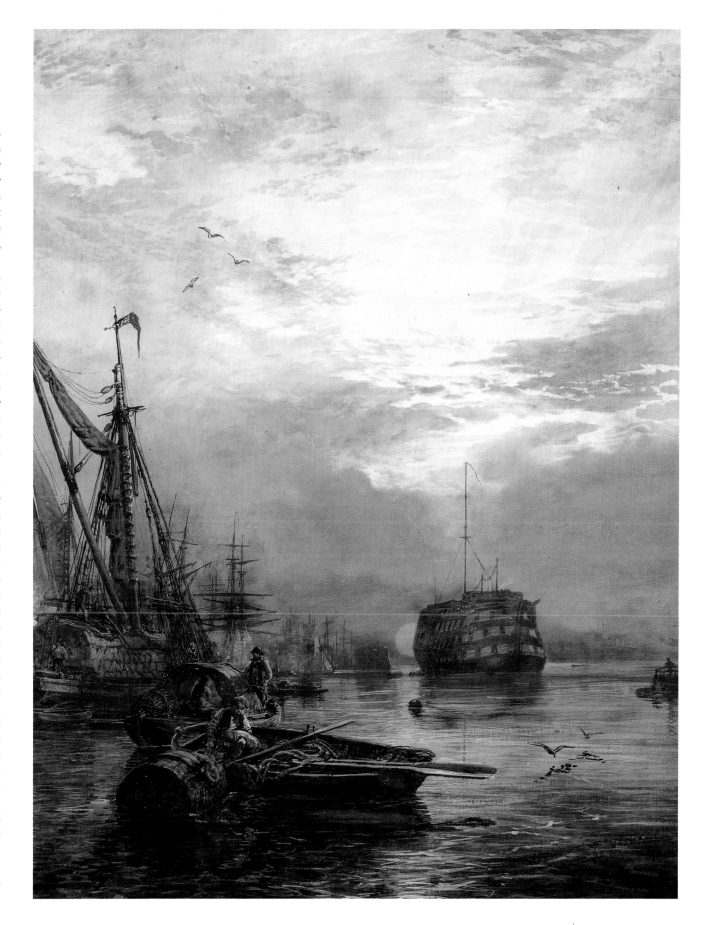

William Thomas Nicholas Boyce

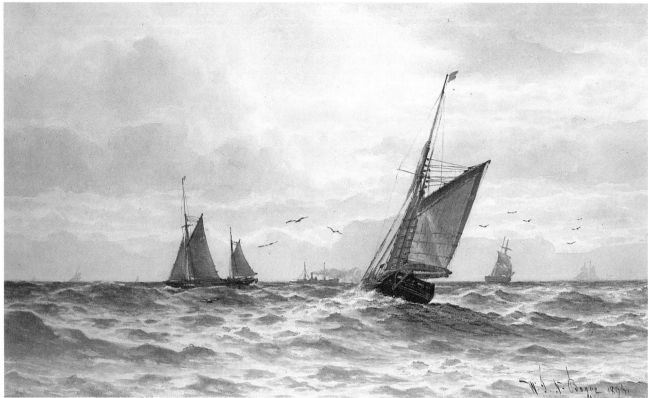

For every professional marine artist there were literally thousands of others who were content to be amateurs, holding down a boring job by day and finding an escape from their humdrum existence through painting in their leisure hours. Content to remain anonymous, some of them nevertheless did eventually become professional painters, though often known only in the area where they lived and worked. What small measure of immortality they did achieve was thanks to the diligent work of a few researchers, and by having some of their pictures hung on the walls of the local art galleries.

Such a person was William Thomas Nicholas Boyce, who painted his marine subjects in a very down to earth way, unlike Stanfield, who brought his sense of the theatre to practically everything he painted. Boyce painted the shipping he saw up and down the north-east coast in all sorts of climatic conditions, but without any fancy embellishments to heighten the mood of a piece, where none were needed.

William Thomas Nicholas Boyce, untitled watercolour, 1896. 11½in x 19½in, David James.

There are two examples of his work on this page. The upper picture is interesting because he has made a point of showing us various types of vessels, including an ironclad in the background, which must have become quite a commonplace sight when this picture was painted in 1896. The other is more traditional, with two of the old-style sailing ships riding the waves, with the usual buoy in the foreground.

Both these watercolours are pleasant, well-crafted examples of marine art, which are probably more restful to live with than some of the more ambitious examples of the genre seen around today.

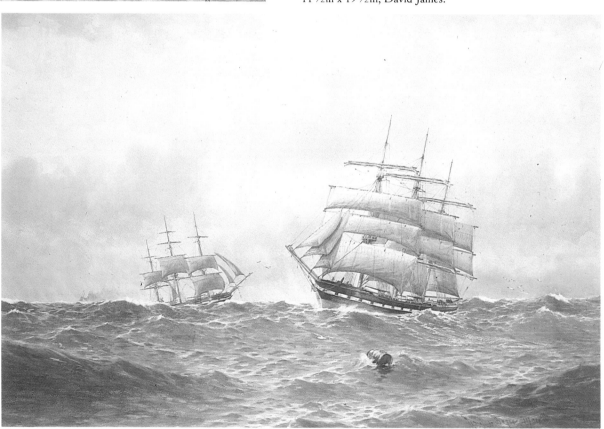

William Thomas Nicholas Boyce, untitled watercolour, 1904. 24¾in x 36¾in, David James.

J. F. Branegan

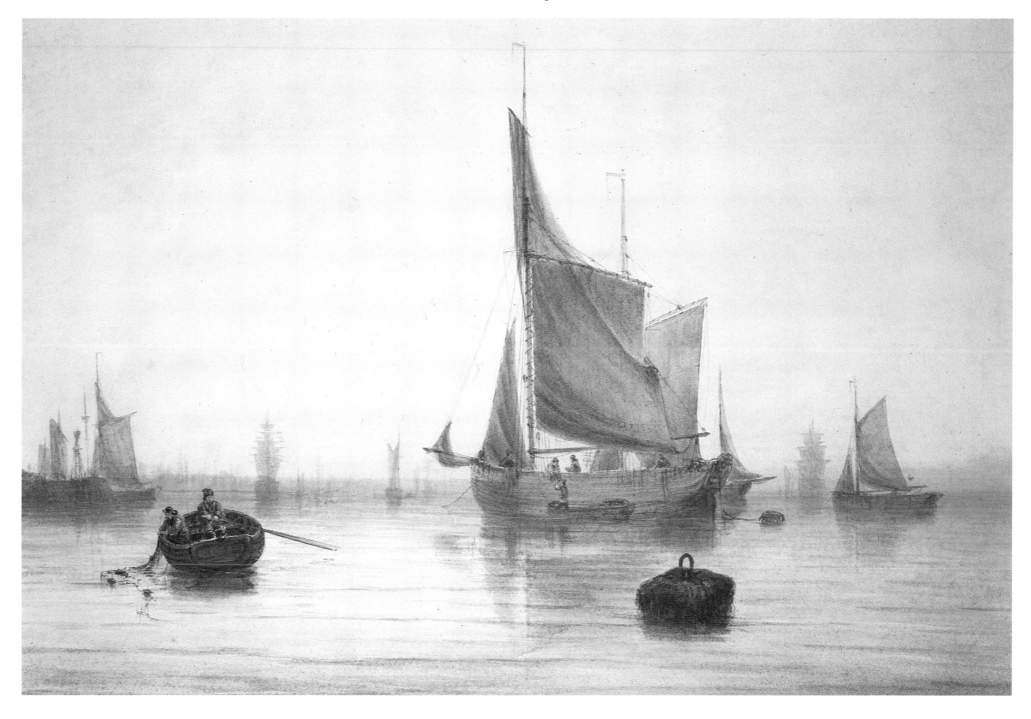

With this painting J. F. Branegan has given us a marine water-colour which has all the atmosphere and look of a rather early nineteenth-century painting, though he was active in the beginning of the last quarter of the century. Studying it, one sees a number of details which are not immediately obvious, such as the way one of the men in the small boat is desultorily trawling with a small net, and how another, this time on the main fishing vessel, seems to be buying something from a bumboat. The gentle ripple on the waters, presaging the beginning of what promises to be a nice day, is particularly well done.

J. F. Branegan, untitled watercolour. 10¼in x 18¼in, David James.

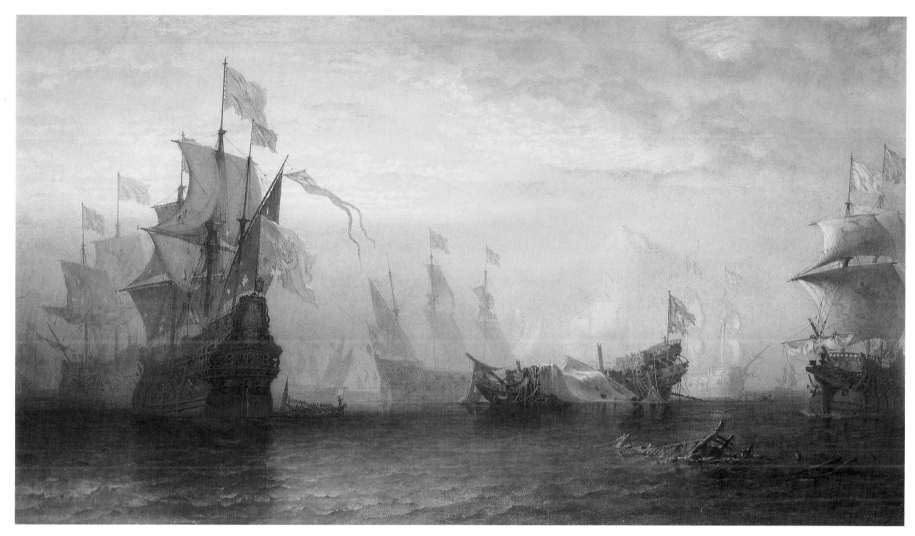

Brierly may have had the prestige of being Marine Painter in Ordinary to the Queen (see page 13) but what really made his name were the lithographs and engravings produced from his watercolours following each of his trips with the Royal Family or the Fleet. These were eagerly bought up by patriotic families and turned his name into something of a household word. They are now highly prized collector's items, and are in themselves works of art.

Rather strangely, his reputation has never really diminished, even though much of his work now seems extremely conventional in its treatment, as one might expect from an artist whose whole life was devoted to pleasing the Royal Family. What saved much of his work from being lumped together with so many of those uninspired large set pieces which had a habit of turning up at the Royal Academy nineteenth-century exhibitions, was the sheer quality of his watercolour painting. In that area of marine painting no one has ever surpassed him. Nor, for that matter, has any other artist stayed so constantly afloat in the pursuit of his career.

In his later years, when he had less in the way of naval engagements to fulfil for the Royal Family, he turned to painting historical naval scenes, a number of them dealing with England's bitter struggle at sea against the Spanish.

His watercolour here deals with the capture of the *Revenge* in the Azores in 1591, when she was cut off from the main English fleet by fifteen Spanish ships manned by 5,000 men who pitted themselves against the mere 250 men on the *Revenge*. Captained by Sir Richard Grenville, she fought for fifteen hours until her last barrel of powder was gone and most of her crew lay either wounded or dead. Mortally injured himself, Grenville was carried on board the Spanish flag ship, *San Pablo*, where he died two days later.

Brierly takes up the story, not as one might have thought, during the height of the battle, with the Spanish squadron slowly pounding the *Revenge* out of the water, but at the very end of the battle with the constant cannonades stilled at last, leaving two of the Spanish sunk and the *Revenge* no more than a shattered hulk. A Spanish boarding party has been over to

the remains of the stricken vessel to arrange the terms of surrender, and has now returned to the flag ship, leaving behind a number of their men and officers to take control of the English ship. It all adds up to a magnificent atmospheric watercolour painting on a subject which stirred the hearts of many a Victorian schoolboy, and even impelled Tennyson to write a heroic ballad on the subject, *The Revenge*.

Oswald Walters Brierly, *The Capture of the Revenge*, 1877.
22in x 36in, Manchester International Fine Arts.

Detail
The greatly enlarged detail shown opposite is of the shattered hulk of the *Revenge*, and brings home by its isolation just how much damage was done by the pounding guns of the enemy squadron, with the mainsail lying across the lower deck like a shroud as the pivotal point of this portion of the picture.

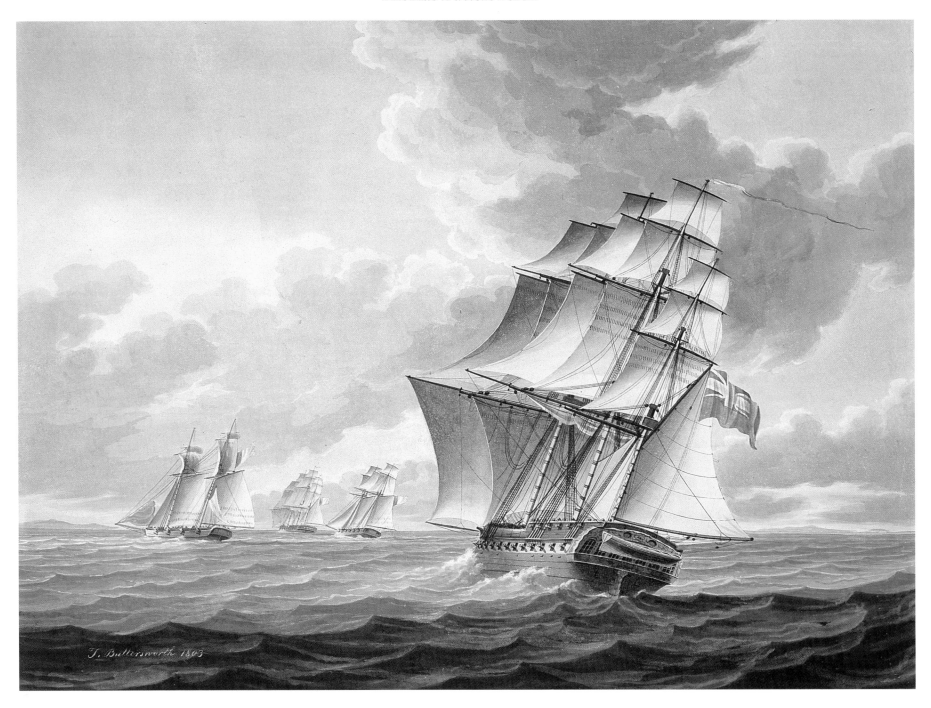

Although he did not belong to the Dutch School of Painters, Thomas Buttersworth painted very much in their style.

A marine painter to the East India Company for a while, Buttersworth was a sound artist with a thorough knowledge of shipping which he displayed in all his watercolours with his highly detailed and accurate drawings. In his watercolour here, he shows us a 40-gun English frigate in hot pursuit of two French schooners and a ship. The nearest French schooner has lowered her ensign to surrender and has come up in the wind,

leaving the other schooner and ship to try and make their escape. It is a watercolour that might be appreciated more by a viewer who has some knowledge of naval history, but this does not really detract from the enjoyment of a painting which has no pretensions to be more than it is — a very nicely painted marine watercolour.

Not much is known about Buttersworth's whereabouts when he was in Britain, though we know he was living in Leadenhall Street in 1827. Seventeen of his works are in the

collection of the National Maritime Museum at Greenwich, and a few others are in the Prints and Drawings Department of the British Museum.

Thomas Buttersworth, *An English Frigate Chasing Three French Vessels*, 1803. 14⅛in x 19⅞in, Royal Exchange Art Gallery, London.

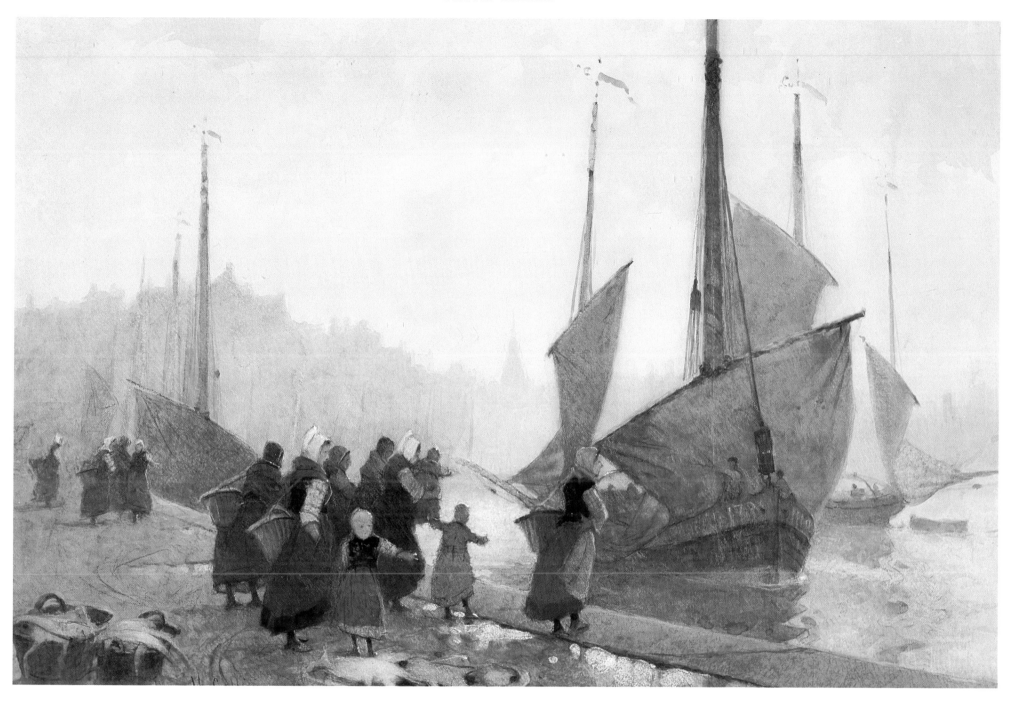

Hector Caffieri, *The Home-Coming Fleet*. 13½in x 20¼in, Sotheby's, Billingshurst.

One of the many pleasing aspects of Hector Caffieri's work is his Boulogne fishing scenes in which the human element is always very much to the fore, rather than the fishing boats themselves. In this example, for instance, it is the wives and the children who have gathered on the beach to welcome the fisherfolk home who dominate the picture, though the boats are still very much in evidence as an essential backcloth. As with so much of Caffieri's work, it is a happy picture that reflects the pleasure of the wives at seeing their husbands safely home.

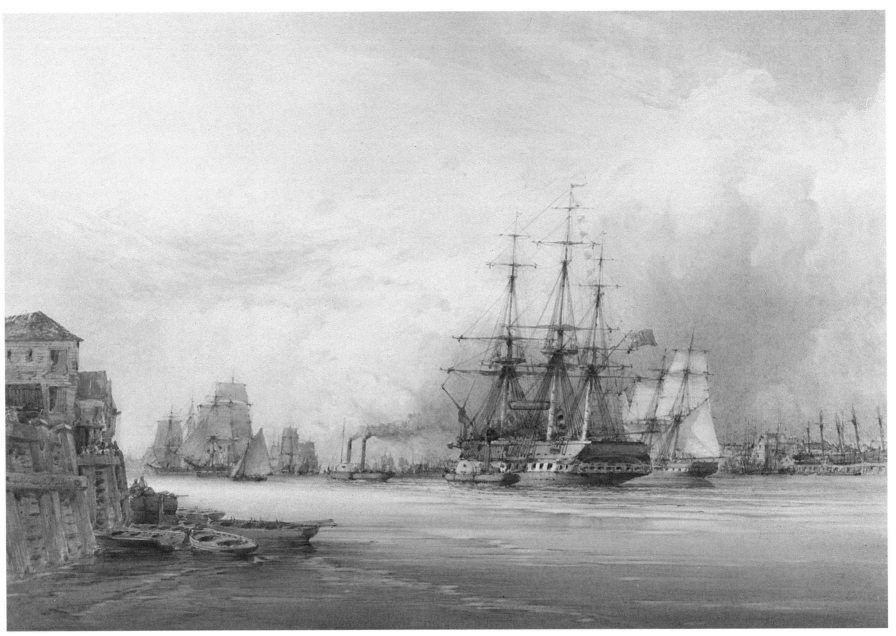

As John Callow's teachers included William Callow, it was inevitable that much of his work was based on his elder brother's style. Both of them had the same sure sense of composition and a facility for fine draughtsmanship.

If there was one thing that John really excelled at it was coastal scenes, taking some of his subjects from places as far apart as the Welsh coast, Normandy and the Channel Islands, all of them vastly different to the other in their coastlines and the way their waters ebbed and flowed under the tidal influences. A firm believer in the use of pure watercolour, rather than trying to heighten his effects with body colour, his work often has a lovely translucent quality about it which is very pleasant and restful to look at.

His watercolour here is of shipping at the Thames's mouth. This is a vastly different Thames to the one we know today, when most of its traffic seems to be either barges or pleasure steamers taking the tourists to see the Houses of Parliament from the river. In the days when Callow painted this, it was one of England's gateways to the world and teeming with vessels of every description, many of them preparing to set off on a journey that could take months.

That John took a great deal of trouble over his work is obvious, if only from the way he has managed to capture completely all the bustling activity of this busy stretch of the river, and in the way he has painted his shipping so that it actually seems to be moving instead of merely lying at anchor, a some-times convenient way for a less talented artist to get himself out of trouble if he felt that his vessels looked unintentionally static.

His work can be seen in a number of museums, including the Victoria and Albert and the municipal art galleries of Glasgow, Leeds and Hartlepool.

John Callow, *Entering the Thames*, 1866. 16in x 20¾in, Fine-Lines (Fine Art).

To say that William Callow was a better marine artist than his brother John is to over-simplify matters. Generally speaking, he *was* the better artist, but John was the more consistently good painter.

William was at his considerable best until around 1850, when he obviously became ambitious and began painting large-scale pictures in the hope they would appeal more to the Royal Academy, who had a liking for that sort of picture at the time. The style did not suit him, and what he produced was unworthy of his talents, though he managed to maintain the high standards of his draughtsmanship to the last.

As it turned out, it did him no good as the public turned against his work and his popularity waned. What made the situation even more tragic was that he still had the ability to return to his earlier form but reserved it for painting purely for his own pleasure. Fortunately for his financial circumstances, his popularity as a teacher of art remained, enabling him to make a very lucrative living from it almost until the last, while still painting very nearly right up to his death.

None of the criticisms that have been levelled at his work apply to his small watercolour shown on this page. Although not dated, it clearly belongs to his earlier period when he was at his best. Note, for instance, the wonderful way he has captured the swell of the sea and the perfect balance of the picture as a whole, with the ancient jetty on the left and the cliffs receding off in the distance, and the rest of the picture taking the eye onwards from left to far right.

What really makes the picture, of course, is the breath-taking sureness of the technique. Compare this with the Clarkson Stanfield watercolour on page 85. Effective though it is in its own right, it is still the lesser picture, with his boats too close together and riding too lightly on the waves, which are positively stylized-looking compared to those painted by William Callow.

Examples of William Callow's watercolours can be seen in the Birmingham Art Gallery, the Bristol Art Gallery, the National Maritime Museum, Greenwich, and the Tate Gallery, to mention only a few of the places where his work may be studied and enjoyed.

It is also worth noting that he illustrated one book, Charles Heath's *Picturesque Annual: Versailles*, published in 1839, for which he supplied the illustrations over a number of years between 1829 and 1836.

William Callow, *Outside Dover*. 8¾in x 12in, Gebr. Douwes.

George Chambers

Chambers was considered by many to have been the most promising marine artist of his generation. In view of the number of contenders for that position, opinions may vary a little today as everyone has their own favourite. No one can deny, though, that he was an extremely gifted artist, whose early death from tuberculosis was a great loss to maritime art.

Although he was successful enough once he had been taken up by George IV (see page 10), he was denied the prestige of being hung regularly by the Royal Academy, whose attitude to him was never more than lukewarm, and who only exhibited three of his pictures in his lifetime. His one true champion was the Old Watercolour Society who made him a full member in 1835 and was a vigorous supporter of his work, hanging twenty-one of his pictures during the short remainder of his life. They were some of the best sea pieces he had ever done and consisted mainly of vigorous studies of ships and shipping, including one he painted on his second trip to Holland, *A Windy Day*, which is now in the possession of the Victoria and Albert Museum.

It was not until this last period of his life that Chambers turned entirely to painting in watercolour, bringing to the medium a welcome freshness of approach, while still using some of the traditional methods of watercolour painting.

In this example of his work, Chambers gives us a vigorous example of marine watercolour painting, with a merchantman scudding before the wind with billowing sails as she makes for port, while another vessel heads out to sea behind her. Under the jetty, from where people watch the progress of the merchantman, we see the occupants of a rowing boat moving out of the merchantman's way.

Chambers has brought these few elements together to make a symphony of sails and sea that evokes in the most wondrous way the golden age of sailing ships, when every voyage, however small, was something of an adventure.

Chambers's work can be seen in a number of museums and art galleries, including the Exeter Museum, the National Maritime Museum at Greenwich, the Leeds City Art Gallery and the art galleries at Newport and Wakefield.

George Chambers, *A Merchantman Entering Port in a Strong Breeze.* 15½in x 21½in, Spink.

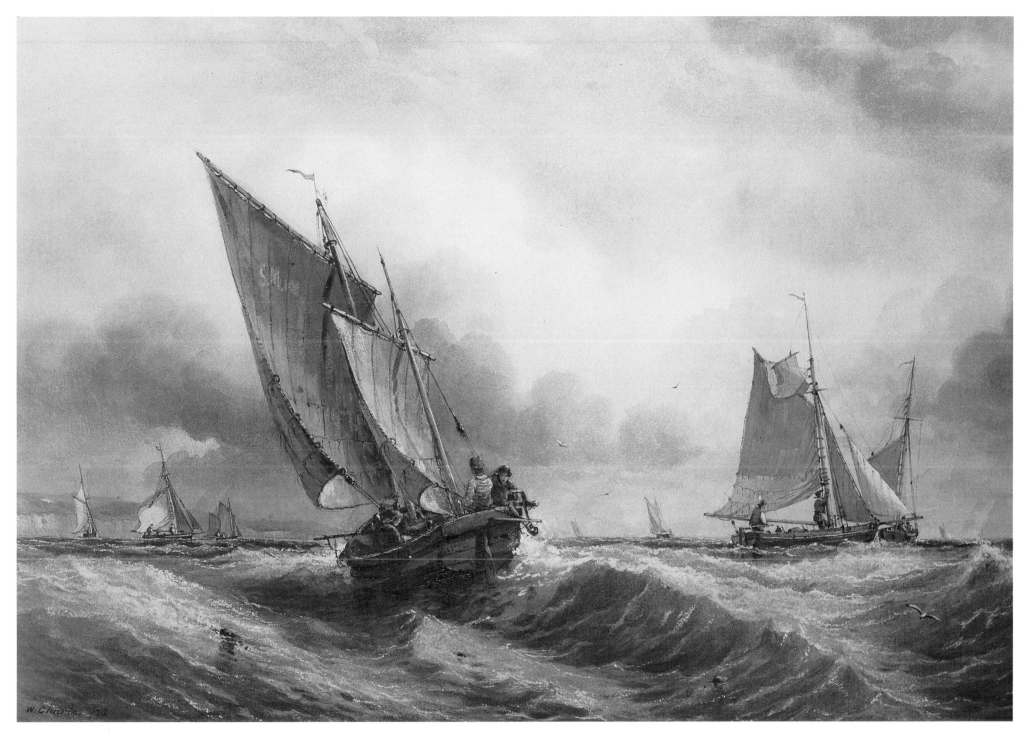

Why so little is known about W. Charles is a mystery, as this is an extremely professional-looking marine watercolour which could hold its own against the work of many well-known artists. It is significant though that he receives a mention in most of the reference books, so his work had not gone unnoticed, small though his output seems to have been. He is known to have exhibited three pictures at the Suffolk Street Galleries from 1870 to 1871, but we know from the date on this watercolour that he was still painting five years later.

The best aspects of this conventional but finely painted painting are the subtle variations of colour in the troughs of the sea, and the care that he has taken over the sails of the vessel in the foreground.

W. Charles, untitled watercolour, 1876. 13in x 20in, David James.

Constable's first efforts at maritime art came about in 1803, when he made a voyage from London to Deal on an East Indiaman at the invitation of the captain, who happened to be one of his father's friends. On the voyage he made some 130 maritime sketches, many of them done when he temporarily disembarked at Chatham, where he hired a boat in order to sketch the men-of-war in the harbour, including the *Victory*. These sketches of the *Victory* were to be invaluable to him when he came to paint his version of the *Battle of Trafalgar* three years later. It was, it has to be said, one of his lesser efforts.

Surprisingly, for all the love and care that he put into working up his maritime paintings, in his later years he had no genuine love of the sea. He considered that sailors led an uncomfortable, squalid and dangerous life, and was greatly upset when his son Charles decided to become a sailor. As his cousin had been drowned at sea, his concern for his son, and his indifference to the sea, were natural enough.

Despite this, and his frequently expressed contempt for all nineteenth-century maritime painting, he spent an inordinate amount of time painting marine subjects. But then, Constable never seemed to be satisfied with what he had painted, often spending years on and off working over a picture before he considered it completed. Frequently he asked for the return of a painting he had already sold so that he might work on it further — sometimes to the annoyance of the patron who was returned a picture that looked quite different from the one he had bought. Even allowing for his inability to leave well alone, his development was unusually slow, and his finest work, with a few notable exceptions, was between his fortieth and fiftieth year.

As with Turner, many books have been written on Constable, and all of them make a special mention of his cloud effects and his remarkable ability to capture all the changing moods of sky and weather, thanks to all the mutations he had observed in the skies while watching them for hours on end when he should have been watching the sails of his father's windmills. Constable himself was fond of writing of what he had seen during his long and lonely vigils. Here he is on rain squalls:

> The clouds accumulate in very large masses, and from their loftiness seem to move slowly: immediately upon these large clouds appear numerous opaque patches which are only small clouds passing rapidly before them, and consisting of isolated portions detached, probably from the larger cloud. These floating much nearer to the earth may perhaps fall in with a stronger current of wind, which as well as their comparative lightness causes them to move with great rapidity; hence they are called by wind-millers and sailors, *messengers*, and always portend bad weather.

Here is a man who clearly knew what he was writing about.

John Constable

Constable once wrote: 'truth in all things only will last, and can only have just claims to posterity'. It was something he strove to observe with everything he painted. Both his landscape and marine watercolours were painted exactly as he saw them, but observed with a heightened sensibility that enabled him to capture the subtle patterns of the clouds as they drifted over sea or landscape.

A typical example is this scene of Folkstone beach with the rain clouds beginning to clear, allowing a pallid rainbow to break through as the clouds begin to roll away.

John Constable, *Folkstone*. Pencil and watercolour, 5in x 8¼in, British Museum.

Although trained to be an engraver, E. W. Cooke made with ease the transition from working with an engraver's burin to painting in oils and watercolours. Other artists had done the same before him, but none of them reached the heights that Cooke did as a marine artist. His ability in his chosen field became so great that when Clarkson Stanfield died, his mantle of being known as the doyen of marine painting fell directly on Cooke's shoulders.

When his father died shortly after he had become a full-time professional artist in 1834, Cooke began making a whole series of trips abroad in what was to become a constant search for suitable new locales to paint. Many of these trips were made to Holland, which he visited sixteen times, his favourite place being Scheveningen, to which he returned time and time again to paint the broad-beamed fishing boats known as 'pinks'. His travels also took him to Venice, North Africa, Germany, Denmark and Sweden, and elsewhere.

However, despite all these foreign excursions he still found time to make an expedition to Cromer, and to paint along the English coast at such places as Brighton, Portsmouth, the Isle of Wight and Deal, to whom he gave a lifeboat named *Van Kook*.

In his way, Cooke was something of a phenomenon. He had an astounding knowledge of shipping, and could paint any ship or boat imaginable down to the last detail, and always with that fine, meticulous line found only in the best engravings. He drew, of course, from hundreds of notes and drawings he had made over a lifetime, which makes it even more remarkable that he was able to pursue other interests quite divorced from his craft. He was a student of botany, geology and zoology, and eventually became a Fellow of four allied societies, including the Royal Society.

The example of his work depicted here is his watercolour *Dover Harbour*, which is almost identical in subject matter to William Callow's version.

As might be expected with an artist of Cooke's quality, his work is to be found in a large number of public art galleries, including the National Maritime Museum at Greenwich, the Victoria and Albert Museum, the art galleries of Gateshead, Glasgow and Leeds, and various national museums in Australia.

This greatly enlarged detail shows in the leading vessel something of Cooke's thorough knowledge of rigging. This is indicated with only gossamer-thin lines which, nevertheless, are still clearly defined enough to be able to see where every line leads. A two-masted coal-burning ship follows in its wake. When sailing on coal, the masts were always reefed, as sparks always presented a hazard.

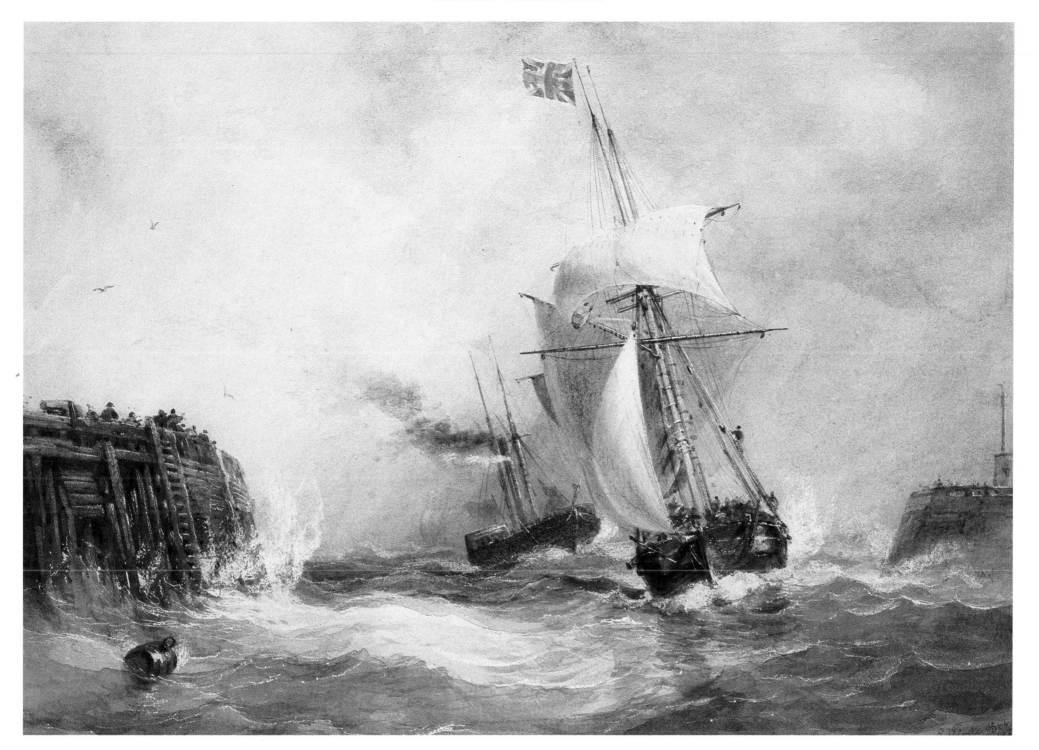

Edward William Cooke, *Dover Harbour*, 1837. 8½in x 12in, British Museum.

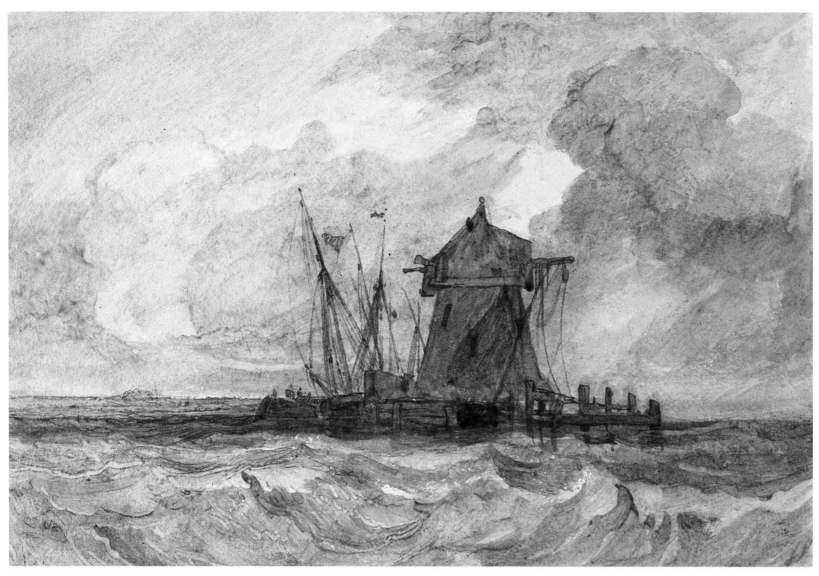

Cotman has always been known primarily as a landscape artist, which is rather to brush aside the very important contribution he made to marine painting.

Much of his work in that genre came about because he hated his work as a drawing master, and welcomed the long summer vacations when he could escape to the sea in the company of his two eldest sons, Miles Edmund and John Joseph, who accompanied him on a large number of excursions when he bought the *Jessie*, which had a small covered cabin to afford them some protection from the strong winds that were apt to blow around East Anglia. While on these trips he sketched away happily, recording the many types of vessels they encountered, which could range from the traditional Suffolk yawls to the occasional man-of-war which sometimes made its appearance in those waters.

The period from 1812 to 1834 when Cotman lived at Yarmouth, occupying a small house near the harbour, was proba-bly his most productive time for marine watercolour painting. Being within easy reach of all the various types of shipping that used that busy harbour gave him a great deal of pleasure, and he spent much of his time industriously making sketch after sketch of the different types of structures and rigging.

In 1831 he sailed from Norwich to London with Miles Edmund on a sketching trip that took them into the Medway, where they stayed aboard sketching everything that passed them by. All this was to be of immeasurable help to Miles Edmund later on when he became a marine artist himself, whose work was to resemble closely that of his father.

One of the favourite subjects for the local painters was the East Anglian wherry, a barge-like vessel used chiefly on rivers to carry passengers and goods, which had been in existence since 1443. Here on this page is Cotman's view of wherries passing a windmill done in sepia wash. To look at it is to under-stand to some degree why he was not a popular artist in his lifetime. This is no tightly executed piece of watercolour paint-ing, but a bold, freely painted example of his work which, with its almost pre-Impressionistic style, shows even by that rela-tively early date just how much the British artists had moved away from the detailed work of the Dutch School of marine paintings. It has a vitality and a beauty all of its own, but it was perhaps a little too much for the worthy burghers of Norwich, even though they professed themselves lovers of the arts.

Examples of Cotman's sea pieces can be seen at the Victoria and Albert Museum and at the art galleries of Birmingham, Manchester and Norwich.

John Sell Cotman, *Wherries Passing a Windmill*. Pencil and sepia wash, 6⅞in x 10¼in, Spink.

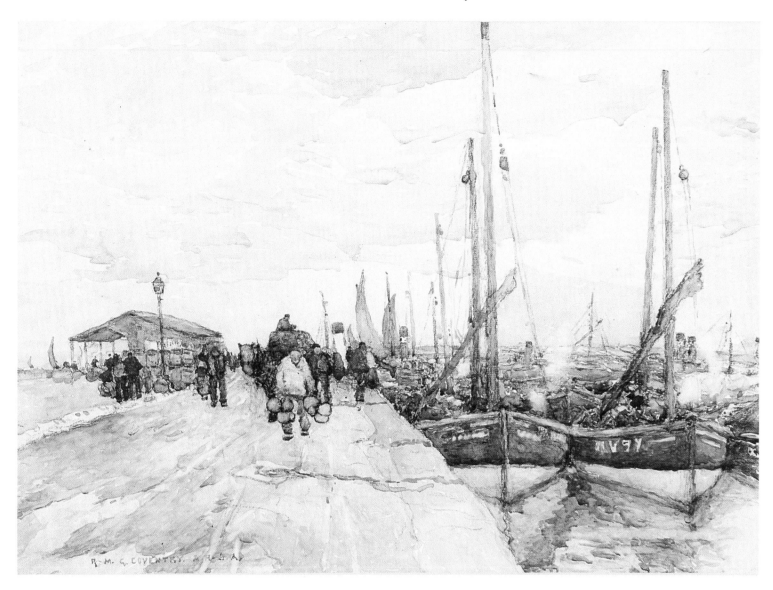

Like a number of other artists, McGown Coventry began his painting career as a landscape artist before he turned to the sea for his inspiration. He began his marine painting around Loch Fyne and Kilbrannon Sound before going further afield in Scotland to paint all number of different types of sailing vessels, and then moved on yet again to Holland, where he became fond of painting the local fishing smacks. But if there was one thing he seems to have been drawn to more than anything else, it was the Scottish fishing quays, which he filled with highly individualistic 'dumpy' figures done in the 'blottesque' style (see page 15).

Coventry was a member of the Glasgow School, an artistic movement which had its roots in the work of the Impressionistic painters like Monet and Degas in France, and with Whistler in Britain. They were given to direct and expressive painting, which sometimes made their work look somewhat coarse against that of the more old-fashioned painters who had always aimed at producing a much more formal and realistic picture. In their own way they were extremely effective, and were the forerunners of modern painting to a minor or major degree, according to how far a painter was prepared to travel along that path. Nevertheless, it was still only a phase in Scottish art, and by 1890 most of its members had either found different ways of expressing themselves, or had vanished from the scene.

Coventry's 'blottesque' effects were highly innovative in their time and make his marine watercolours some of the most interesting of their period. With his technique, the 'blobs' of colour were carefully placed against large areas of pure wash to obtain the maximum effect.

His watercolour of Anstrauther Quay on an overcast day is very representative of his work, and looks as if it could have been painted yesterday. With this watercolour he proved, as Cotman had done earlier with his wherries opposite, that the limitations placed on art are not always governed by the willingness of the viewer to accept something other than the conventional. The figures on the quay, done in Coventry's inimitable style, may be blobbed on the paper here and there, but they all have the plasticity of the human form and stand or move in the most natural manner.

Robert McGown Coventry, *Anstrauther Quay — Glasgow.* 14¾in x 21in, Fine-Lines (Fine Art).

Ernest Dade

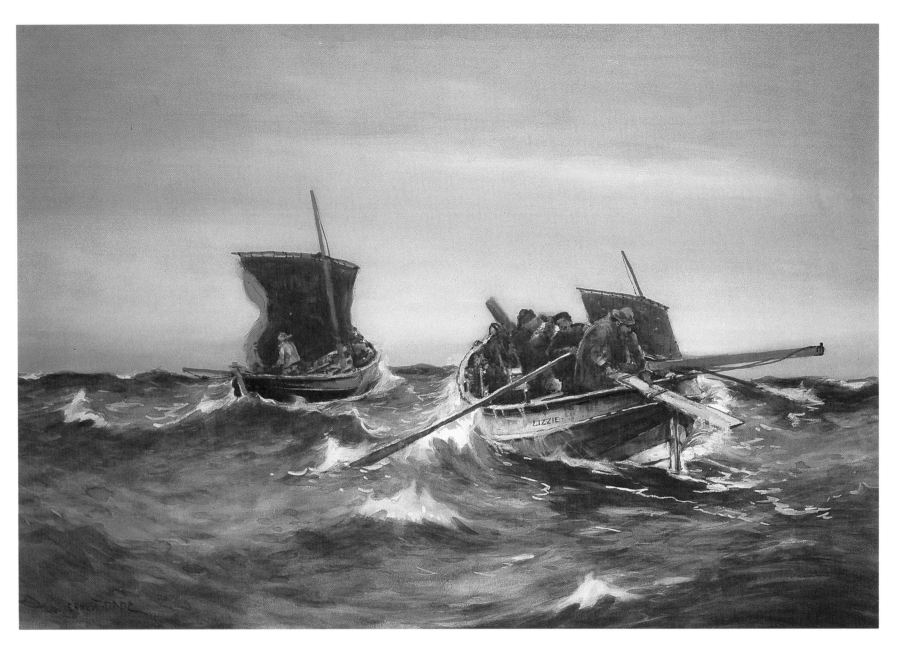

A very late nineteenth-century marine artist who died in 1935, Dade exhibited nineteen pictures at the Royal Academy. His watercolour here is of cobbles, or cobles as they are sometimes called, a sea fishing boat with a flat bottom, lug sail and a rudder extending four or five feet below, which is still used on the north-east coast of England. The picture itself is a well-composed one, painted with bold and assured brush strokes and full of movement as the two boats ride the choppy waves.

Ernest Dade, *Fishing Cobbles in the North Sea.* 19½in x 28¼in, David James.

John Wood Deane was an amateur painter who was obviously capable of painting a more than competent watercolour, as can be seen from this very unusual painting which gives us a rare opportunity to see the great naval establishment of Portsmouth as it looked in 1840. The Fleet lies quietly at anchor while two buglers take their ease by the battery gun, with the massively built ramparts as a backcloth. It is a picture which must be of interest to historians as it shows how close the residential houses and a church were — presenting an open invitation to have them all demolished if some enemy vessels had chosen to sail in with all guns blazing. This was not so unlikely as it might seem, otherwise those formidable-looking defences would not have been there.

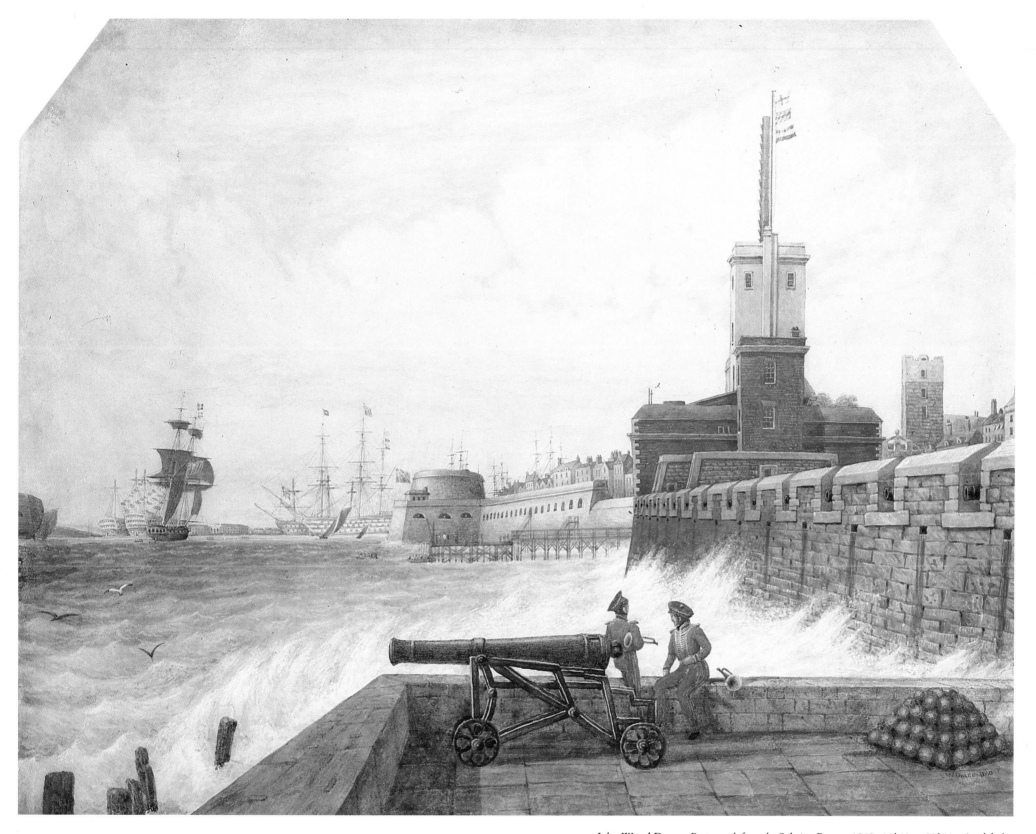

John Wood Deane, *Portsmouth from the Saluting Battery*, 1840. 16$\frac{1}{8}$in x 20$\frac{1}{8}$in, Appleby's.

When Charles Dixon painted this picture the golden age of sail had almost come to an end. Where graceful-looking vessels with billowing sails had once made their way silently and majestically to the Thames mouth and the sea, there was now a hideous mêlée of noisily hooting steamers and tugs fighting each other for space in the over-crowded waters. The heavy thudding of engines and the smell of dozens of belching funnels had replaced the sound of slapping sails, turning the whole scene into something that had the quality of a nightmare when seen through Dixon's eyes.

One would have thought that this a view such as this might have driven any marine artist very quickly into open waters, where at least there was space to move in an atmosphere mercifully free of any pollution. But some artists loved painting this sort of scene, which gave them an opportunity to break away from the now perhaps all-to-familiar views of ships and trawling fishermen. The most notable of them all was Charles Dixon, who returned time and time again to the Thames to paint in his immediately recognisable style all the bustling activity that went on there.

The traffic of boats, barges, tugs, ocean-going steamers and occasional sailing ships seems quite incredible when compared with the well-organised activities going on in the Thames today, but it is certain Dixon did not exaggerate as other artists of the period have painted not dissimilar scenes.

Examples of his work can be seen at the Aberdeen, Blackpool and Newport municipal galleries, and at the Maritime Museum at Greenwich.

Charles Edward Dixon, *Port of London*, 1864. 20in x 30in, The Priory Gallery.

William Croxford Edwards, *Dutch Fishing Boats, Scheveningen*, 1873.
19in x 35in, David James.

If there were any places that the nineteenth-century marine artists favoured more than anywhere else when going abroad to paint they were Venice and Scheveningen. Being nearer to England it was the latter which was most visited, with the result that we have a legacy of dozens upon dozens of watercolour scenes of this famous Dutch fishing village.

Inevitably, much of what was painted there has become boring to look at by the repetitious nature of its subject matter. There are, after all, only so many viewpoints you can paint of beached boats and fisherfolk gathering on the shore. For some reason the artists who went there never seemed to go in for portrait painting, as did the Newlyn artists who were to make a whole 'school' from their studies of local fisherfolk.

Occasionally, however, an artist who went to Scheveningen transcended his subject matter by something as simple as his use of colour. William Croxford Edwards was such an artist. With his watercolour *Dutch Fishing Boats, Scheveningen* he has painted a picture in which his use of colour is so appealing that it can bring only joy to anyone fortunate enough to have it on their wall.

Hector Caffieri deals with an almost identical subject in his watercolour *The Home-Coming Fleet* on page 45. His is more light in spirit and perhaps a little more romanticised, while the figures in this watercolour are more stolid looking and the picture itself rather in the manner of an old Dutch Master. But it is not the subject matter which makes this Edwards painting, but the range of muted colours which have been applied to give it a lovely translucent look, and the general appearance of a hand-coloured old print.

59

As we move into the last quarter of the nineteenth century, subtle changes were beginning to take place in the art of marine watercolour painting. Instead of the tumultuous storms at sea and ships with full sail running before the wind, there was now a tendency to paint something quiet and reflective. Atmosphere had become more important than action, the interplay of light and sun on the sea more valued in a painting than an attempt to recreate in every detail a complicated piece of rigging — though this still played an important part in marine painting as so many of its practitioners had once been sailors.

Arthur Henry Enock was very much a painter in this mould and has always been best known for his handling of mists and sunlight. This watercolour is a typical example of his work, with the early morning mists lifting to reveal an almost mirror-like calm sea with *HMS Enterprise* riding quietly at anchor. It is interesting to note that although he belonged to the new school of painters, Enock still took enormous pains over the rigging, which is shown down to the last detail.

Arthur Henry Enock, *HMS* Enterprise *in Dartmouth Harbour*. 15³⁄₄in x 23¹⁄₂in, David James.

Anyone who ventures into the field of art criticism steps on to dangerous ground, especially when it comes to trying to give a careful assessment of an individual artist's work. Never was this more evident than in the case of J. M. W. Turner, whose work was rejected by the critics of his time, with a few notable exceptions.

To a lesser degree this may also be said of Copley Fielding, who was greatly admired by Ruskin who devoted several pages to him in his *Modern Painters*. On the other hand, others have spoken of his work in almost dismissive terms, including one who caustically brushed him aside as being a repetitive artist with only 'one sea, one moor, one down, one lake, one misty gleam'. Even as late as 1925 an art critic commented that 'it was only Fielding's sympathetic rendering of atmospheric effect which saved his painting from being mere hack work'. This went against a judgement of him in the last English edition of the *Encyclopaedia Britannica*, published in 1910–11, and still regarded as the best edition of the *Britannica* ever produced. In this, their unknown biographer of Fielding referred to him 'as being a painter of much elegance, taste and accomplishment, who had always been highly popular with purchasers'.

He has remained a popular artist to this day for the same reasons that made him popular in his own time. His subjects were chosen for their likely appeal and he used colours that he knew the public liked — yellow, purple, brown and indigo. His liking for the latter has worked against him in the long term, as many of his watercolours where he used that colour have faded badly.

He was not the major artist that Ruskin claimed him to be, but he was still a very good one, even though some of his work was indeed repetitious and sometimes a little too 'pretty' for everyone's taste. He painted in both oils and watercolours, but his reputation rests mainly on his watercolours.

His two watercolours here are totally different in appearance, but both of them have been composed with an engaging simplicity. What could be more pleasing to the eye than his two fishing boats beached on golden sands, while the fishermen dismantle their sails? In the far background on either side of the boats are two distant sailing boats which help to give some depth to the watercolour. It is a picture to which the word 'pretty' could be applied in the best sense of the word.

The other watercolour (b) of fishing boats in a breeze is a more dramatic affair of darkening skies and choppy waters warning of an impending storm at sea, one of Fielding's favourite marine subjects. The channel of white racing surf cutting across the picture highlights the fishing boat and also lightens a picture which would otherwise have been rather drab.

As a result of his enormous output, examples of Copley Fielding's work can be seen in many art galleries throughout the country, including those at Blackpool, Coventry, Doncaster, Eastbourne, Exeter, Glasgow, Leeds and Manchester.

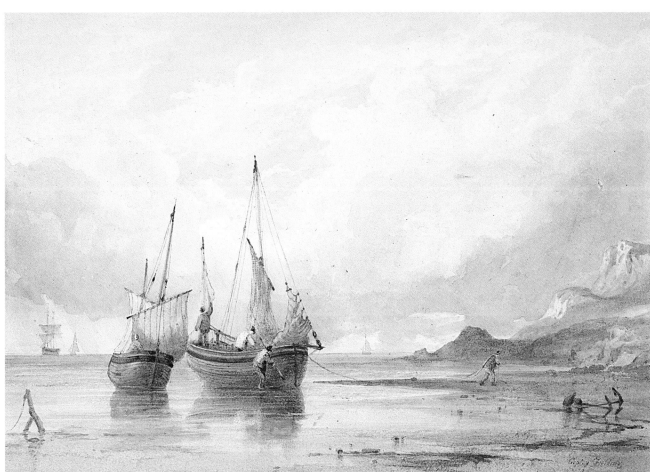

(a) Copley Fielding, *Beached Fishing Boats*, 1825. 7¼in x 10½in, J. Morton Lee.

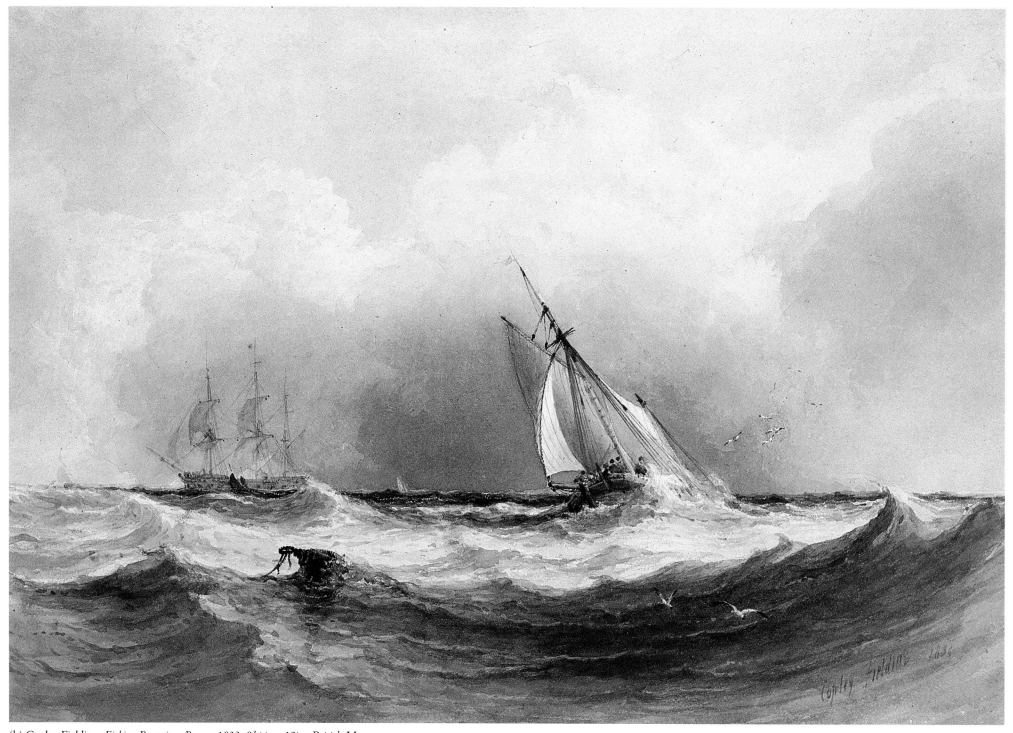

(b) Copley Fielding, *Fishing Boats in a Breeze*, 1833. 8¾in x 12in, British Museum.

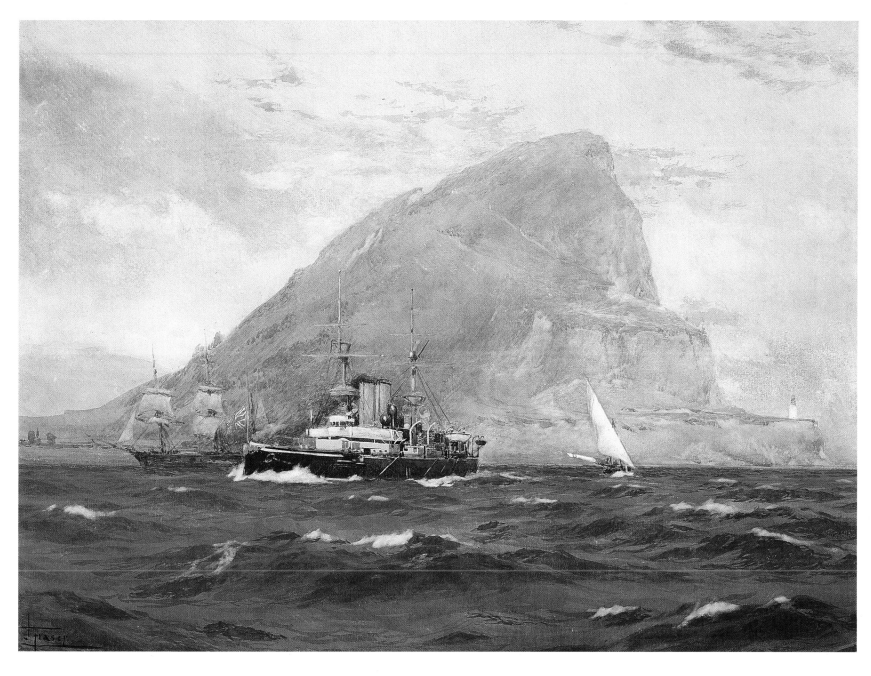

John Fraser's work was greatly influenced by Thomas Somerscales (1842–1927) and Edoardo de Martino (1838–1912), a larger-than-life character who had received his nautical training at the Royal Naval College at Naples and had gone on to become a highly successful marine painter to several crowned heads of Europe, as well as being official marine artist to the Royal Yacht Squadron at one time. When Martino found himself with more commissions than he could handle he went to Fraser to paint them, afterwards adding a few touches of his own before passing them off as his own work.

Fraser exhibited regularly at the RA from 1885 to 1919. In the 1950s the National Maritime Museum bought the residue of his collection of sixty oil paintings and more than a hundred watercolours, as well as a large number of his sketchbooks. His work may also be seen at the Exeter Museum.

His watercolour here is a well-executed one, and is interesting from an historical point of view as it shows a late Victorian warship off Gibraltar, when they were still painted with black hulls, white superstructure and cream funnels which made them look far more attractive than the grey-coloured warships of today. It is a bright, sparkling piece of work in which all the emphasis is on the warship and the sea, painted in a rich blue.

John Fraser, *HMS* Barfleur *in the Straits of Gibraltar*. 17in x 23in, Royal Exchange Gallery.

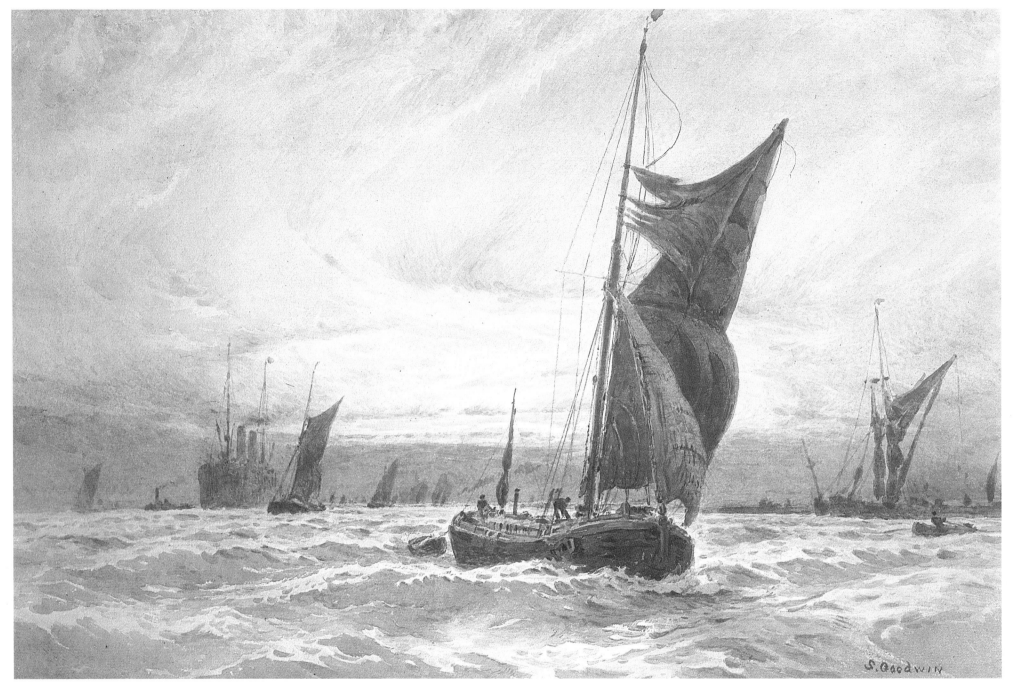

This is a busy watercolour, as one might expect with an artist dealing with the Thames, a river used by everything from a rowing boat to a liner — the latter seen here edging its way through a whole number of sailing vessels. Although the main focal point of the picture seems to be the barge in the foreground, the watercolour obtains its main effects from the cirrus-like clouds tinged with orange from the last of the sun, and from the way that Goodwin has managed to capture so well that characteristic chilly look the sea takes on just before the day fades into night.

Sidney Goodwin, *Shipping on the Thames*. 17in x 21in, David James.

Charles Gregory

Charles Gregory, *A View of the Island Sailing Club, Isle of Wight, with the Royal Yacht Club and Sailing Vessels Moored Offshore*, 1867. Pencil and watercolour, 11¾in x 20¾in, Bonhams.

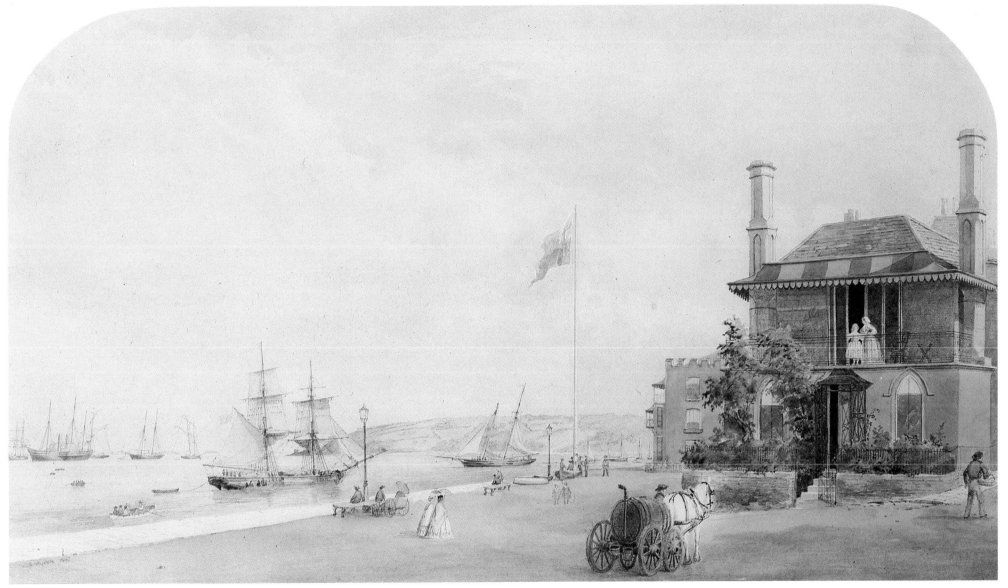

Many of the major marine artists visited Cowes to paint or to visit their friends stationed at the Royal Yacht Squadron which had been there since 1812. Strangely enough though, considering the opportunities there were for a marine painter, very few of them actually lived there. A few notable exceptions were Arthur Wellington Fowles (fl. 1840–60) and Charles Gregory and his son George, who became a painter of local scenes.

Gregory's watercolour evokes a past when Cowes was little more than a small watering-place supporting an industrial population chiefly employed in shipping yards, and frequented by naval officers and their ladies, and painters who spent most of their daylight hours painting the enormous variety of vessels that lay moored in the harbour.

Thomas Bush Hardy

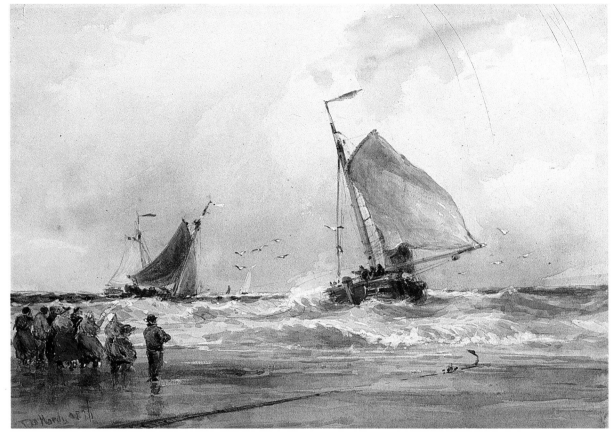

Hardy was an artist whose work could range from downright bad to first class, depending on how quickly he needed to raise money, which seems to have been most of the time, even though his work sold very well. Nor was his potential to be even better helped by his facility to produce acceptable work at great speed. Denys Brook-Hart in his book *British Nineteenth-Century Marine Painting* tells the possibly apocryphal story of Hardy setting up as many as ten easels at once and then getting down to work on all of them at the same time.

Having said all that, one must add that many of his marine watercolours were excellent and delicately executed coastal studies, especially those he painted at Scheveningen and other foreign fishing villages, to which he seemed to respond more readily than many of his English subjects. He was a popular artist catering for a popular market, and like so many of the nineteenth-century artists his output was enormous.

But perhaps Hardy needs no apologia. After all, his work is to be found in museums all over the country, and he is as popular today with the public as he was in his own lifetime, a reminder that it is the public who buys pictures, not critics.

His work at its best may be seen with his two watercolours on this page. Both the subjects are the familiar ones of a foreign beach, from where the local fishermen went out with their nets. With his watercolour of Scheveningen beach the approach is very different from that of Croxford Edwards on page 59. His was painted in subdued colours and seems to belong to a distant past, while Hardy's boats riding the surf on a breezy day are boldly painted and give the impression of being done at a much later period.

The other watercolour *Low Tide at Cape Gris-Nez* (b) is handled in a different manner. Here, the figure work is much more detailed and there is more emphasis on tonal values, with the large area of wet, dark sand making a sharp contrast to the edge of the dunes, which seems to be a place for everyone to meet and gossip.

Hardy's work may be seen at such places as the art galleries of Bradford, Dundee, Eastbourne, Hartlepool, Leeds, Manchester and Newport.

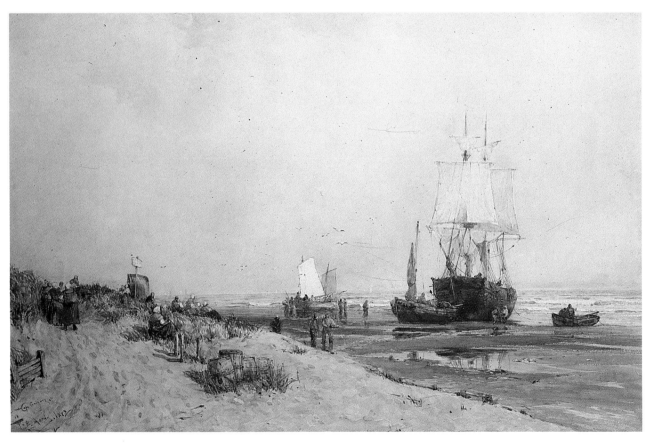

(a) Thomas Bush Hardy, *Scheveningen*, 1871. 6in x 8in, Priory Gallery.

(b) Thomas Bush Hardy, *Low Tide at Cape Gris-Nez*. 12in x 20in, David James.

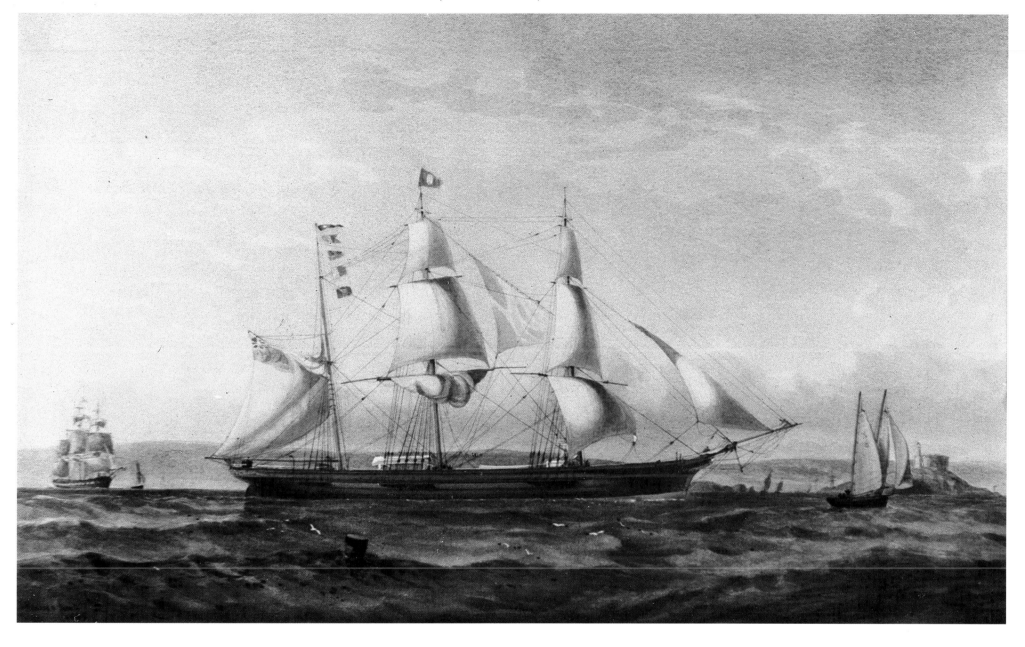

This marine watercolour is a particularly fine example of the work of James Harris Junior, whose paintings are not seen all that often. Thanks to a great deal of research on this artist carried out by Peter Ferguson of Barnstaple, a well-known local historian, we are able to identify it as the barque *Lieutenant Maury*. She is seen here in Caldy Roads, with Castle Hill and St Catherine's Island Old Fort in the background, preparatory to her record-breaking run to the west coast of South America on her maiden voyage in 1865. The pilot boat is the *Glance S6*.

Some examples of Harris's work may be seen in the Glynn Vivian Art Gallery, Swansea.

James Harris Junior, *Off the Mumbles*. 11½in x 18¾in, J. Collins & Son.

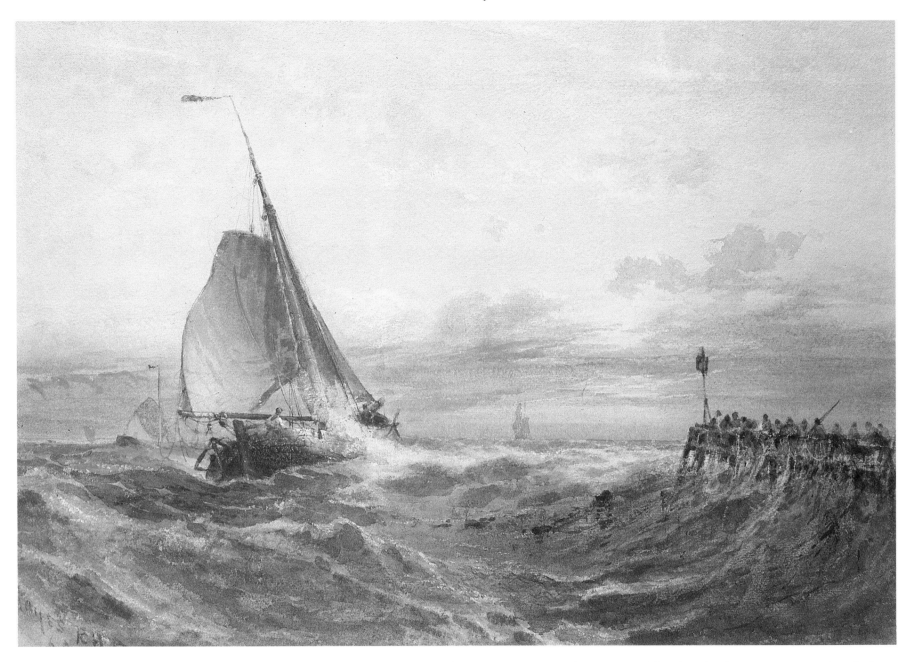

Edwin Hayes was one of the few artists whose life seems to have proceeded on a permanently even keel, with nothing to mar a rather pleasant existence. At the end of it, he could look back on a successful marriage and a career that had steadily progressed from one modest triumph to another, starting from when he exhibited his first picture *A Scene at Ryde* at the British Institution, to when he painted his *Sunset at Sea* in 1894 which was bought by the Chantrey Bequest. It is now with the Tate Gallery and was the only picture he painted in which the subject was simply sea and sky.

He had eleven children, including Claude Hayes (1852–1922) who became a very successful portrait and landscape painter until ill health and the constant pressure of money problems began to have an effect on his work. The father travelled and painted in France, Holland, Spain and Italy, but it is for his English watercolours that he is best known, most of them painted on the south coast. Many of them are reminiscent of Clarkson Stanfield, and all of them show a keen eye for nautical detail, acquired during his time as a sailor (see page 26).

He was a man who had been obsessed with becoming a marine painter from the time he could think seriously of what he was going to do. How well he succeeded can be judged by the high quality of his watercolour here, *Yarmouth Roads*. The fishing boat heading out to sea past the onlookers on the jetty, the waves breaking over the side of the boat as it goes by, and particularly his treatment of the sea, all add up to make a spirited piece of marine watercolour painting.

His work may be found in many art galleries both abroad, and in England at the Bristol City Art Gallery, the Welsh National Gallery at Cardiff, the Shipley Art Gallery, Gateshead, the art gallery of Leeds, and the National Maritime Museum at Greenwich.

Edwin Hayes, *Yarmouth Roads*. 12¾in x 18½in, David James.

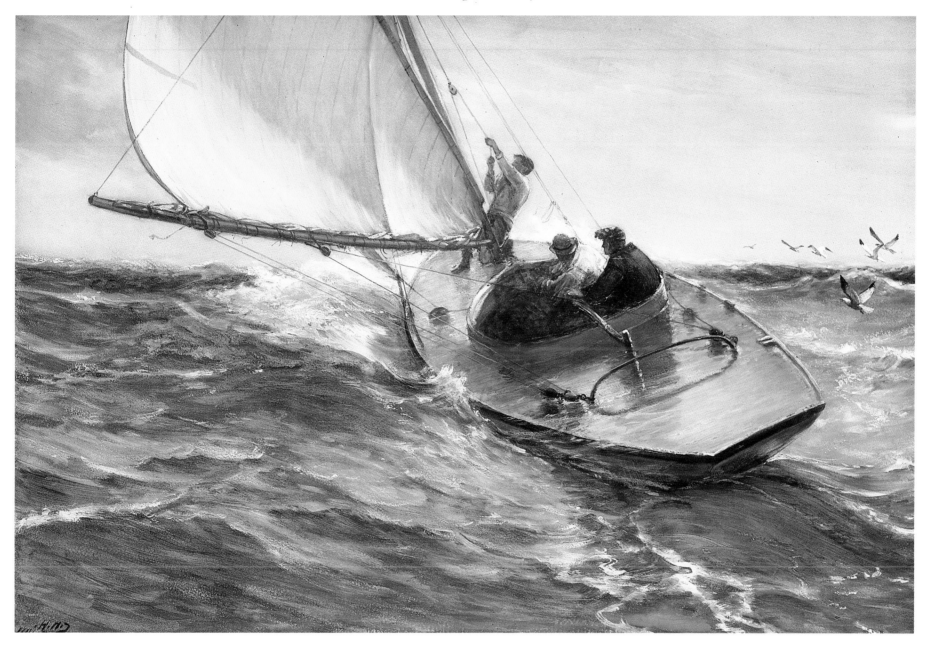

One of the complaints that has been levelled at marine paintings by non-sailing people is the lack of large human figures in them. It is true that in many of the paintings the crews *are* seen only as distant figures, if they are seen at all. There were many exceptions, of course, including Robert Anderson's *Herring Fishing* on page 35 where the fishermen are seen at close quarters. Another was Charles Napier Hemy's magnificent watercolour *Living*, which he painted in both watercolour and oils. But then Hemy was a realist who was far more interested in painting men at work on the sea than in painting ships or yachts against a setting sun, or painting any form of vessel for

its own sake, however accurate. The problem for artists wanting to paint this sort of picture has always been the difficulty in getting near enough to the subject to record it with any degree of accuracy. It was one that Hemy solved, as others had done, by buying his own boat which he named the *Van de Meer*. With his watercolour *Living* we are so close to the men grappling with their sails as almost to be sailing with them.

Hemy's style became more bold as he grew older and even veered occasionally towards the Impressionistic. But his deep love of the sea continued to be evident in everything he painted, as he never allowed technique to become the main

consideration. He was one of the great marine artists of his time, whose reputation was further enhanced in 1897 when the Chantrey Bequest bought his painting *Pilchards*, which can be seen at the National Maritime Museum at Greenwich where it is on loan from the Tate Gallery.

Other examples of his work may be seen at the art galleries of Blackpool, Manchester and Newcastle.

Charles Napier Hemy, *Living*. 26in x 40in, Royal Exhange Gallery.

Alfred Herbert

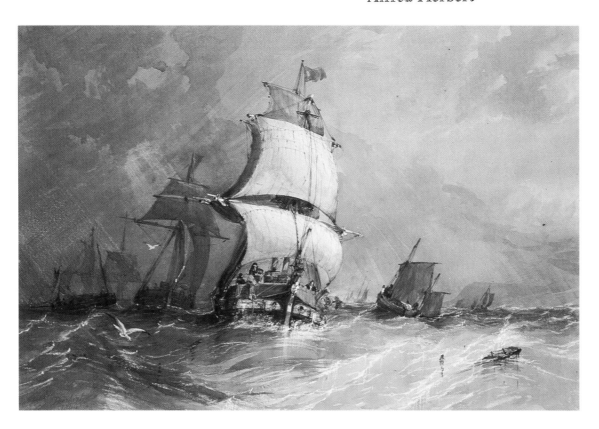

Herbert's style of marine painting was not unlike that of John Callow, but for some unknown reason his work never enjoyed the same success. It is difficult to understand why. His work was highly professional and could be most attractive looking, as we can see from the two watercolours on this page.

His watercolour (a) showing a number of different craft running before the wind is very much in the traditional manner of his time, with the emphasis on a brig coming towards us without any headsails set, which was a dangerous piece of seamanship, especially among so many other nearby craft. Astern of her is a topsail schooner heeling in the wind, while close on either side are fishing luggers. Note the rain squall on the right, beginning to blot out the headland.

Watercolour (b) is totally different in its whole feeling, look and colouring, and gives us some idea of how versatile this artist could be. Added interest of a non-nautical nature in the picture is that it does give some idea of how St Malo looked in those days, with its characteristic Normandy houses, some of them built centuries before this was painted.

Examples of Herbert's work can be seen in the Victoria and Albert Museum, and the art galleries of Blackburn and Blackpool, as well as the Grundy Art Gallery in Southend.

(a) Alfred Herbert, *A Brig, a Schooner and Other Craft in Thick Weather*, 1844. 11¾in x 17½in, Royal Exchange Gallery.

(b) Alfred Herbert, *St Malo*. 17in x 33in, David James.

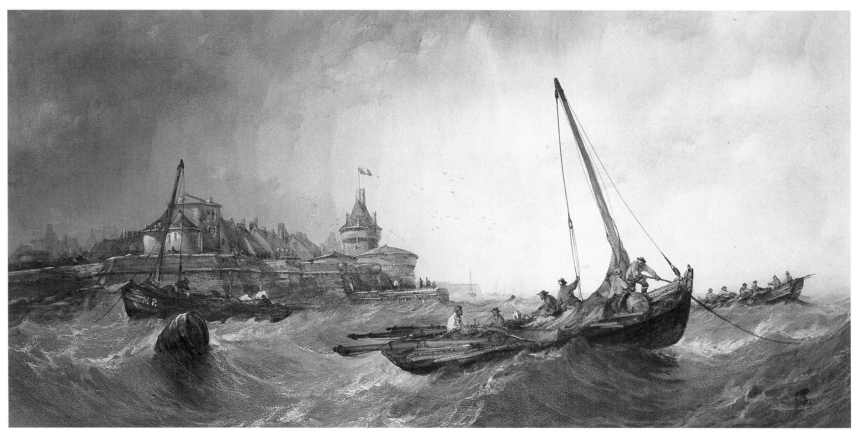

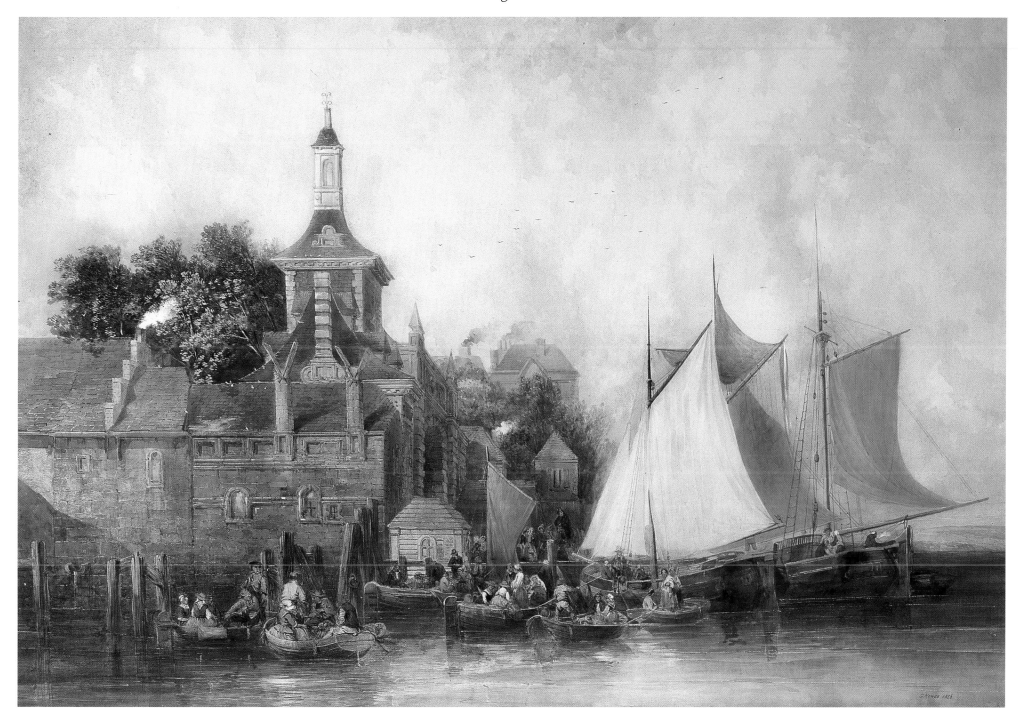

Howse's watercolour of the old port of Rotterdam reflects his two main interests as an artist. Already well known for his architectural studies, he would obviously have been attracted to visiting Holland, where the architecture was vastly different to ours, and would therefore have presented him with an interesting challenge. Equally well known for his English coastal scenes, he would also have wanted to try his hand at painting Dutch vessels, a subject which had already attracted artists in their droves to Holland.

These two facets of his art are synthesised in the one painting, with the added attraction of a great deal of entertaining and highly detailed figure work, as a whole variety of people prepare to land or embark from Rotterdam.

George Howse, *The Oudehoofdpoort at Rotterdam*, 1858. 27½in x 39½in, Appleby's.

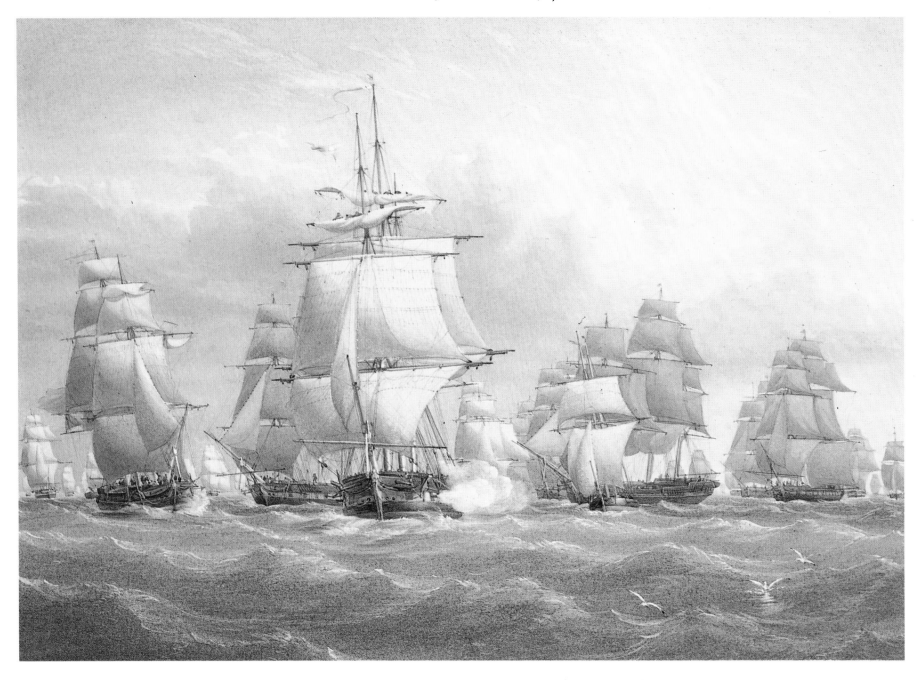

Although the two brothers generally worked together, painting in an almost identical manner, it was William who was the better artist when it came to painting a storm scene. He worked both in oils and watercolours, unlike his brother John, who was almost exclusively a watercolour artist, often using the evening light for his effects.

Despite their occasional defects as artists, which was a tendency on John's part towards weak figure work, and William's misguided habit of using the wrong sort of green for his seas, they were still accomplished artists, whose training as draughtsmen stood them in good stead when it came to painting all the nautical details of a ship. Many of their watercolours have an affinity to the Dutch Masters of the early eighteenth century.

Their joint effort on this watercolour is an interesting one in that it shows something of the merits of their work with its careful attention to the setting of all the sails, which is correct down to the smallest detail. In the picture some of the English fleet is sailing towards us, accompanied by what appear to be merchant vessels, suggesting that this is a convoy with a few men-of-war in charge. The leading man-of-war has hoisted a burgee (pennant) and is firing a signal gun, presumably to indicate an order.

A number of the brothers' watercolours can be seen in the City Art Gallery, Birmingham, the National Maritime Museum, Greenwich, the Castle Museum in Norwich, and the Graves Art Gallery, Sheffield.

William and John Cantiloe Joy, *A Fleet Under Sail in a Stiff Breeze*. 11¾in x 16¼in, Royal Exchange Gallery.

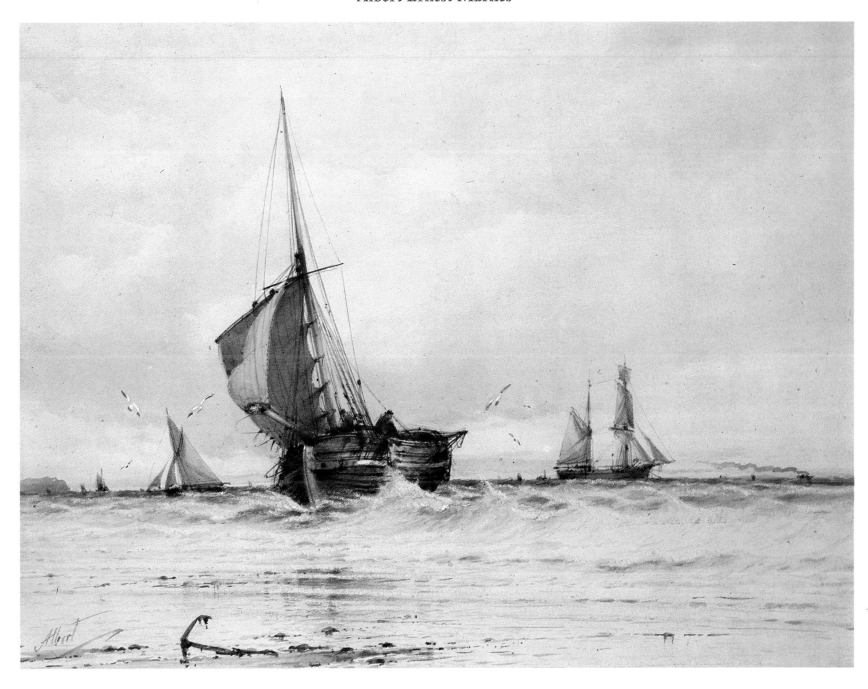

Markes had the misfortune to be colour-blind and only able to use one eye. Obviously this was an enormous disadvantage for any artist to labour under, and as a result a large number of his watercolours are lacking in colour. In some cases, however, his muted colours worked to his advantage, as they made a welcome change from the more strongly painted work of many of his fellow marine artists.

The lack of colour is apparent in this watercolour, but it is not something of which one is really conscious, as the merits of the painting lie in its simplicity and the sense of space and airiness it has, common to many of his paintings. Markes obviously made a quick sketch on the spot and then worked the watercolour up in his own home, adding the two small boats to give something on the skyline, while at the same time using them as a balance to the boat coming in to beach on the sands.

Albert Ernest Markes, untitled watercolour. 10¼in x 13½in, David James.

Paul Marny

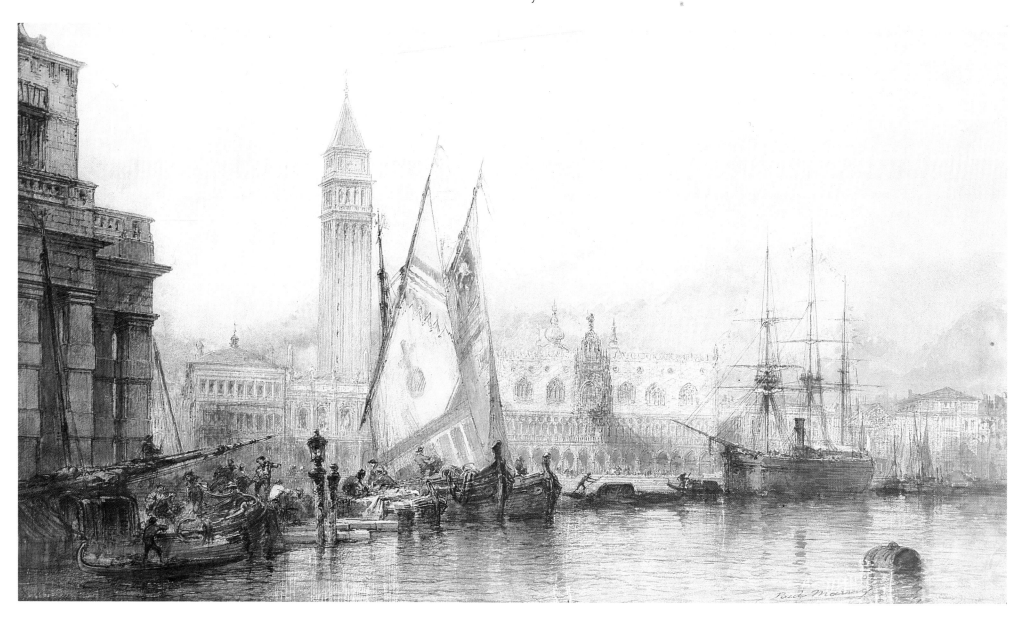

Nearly all the marine artists travelled abroad to paint at some time during their working lives. Those who were chronically short of funds still took themselves off to Scheveningen, though towards the end of the nineteenth century the attractions of painting this famous Dutch fishing village were beginning to pall, mainly because the art market was now glutted with pictures which had been painted there.

But there was still Venice, which had become the pleasure city of the world, where art, architecture and water met in surroundings unrivalled by anywhere else. For artists its attractions were twofold. They could study the work of the great Venetian masters, and they could paint away to their heart's content the enormous variety of shipping that could be found along the Grand Canal, with places like the Doge's Palace or the church of Santa Maria della Salute as superb backcloths. There was, too, the added bonus of that wonderful Mediterranean light which lent itself far more readily to being caught in watercolours than in oils.

Paul Marny, who was not known to have done much travelling once he had left his native France and settled in Scarborough, probably went off to Venice while he was still living in France, where he is thought to have been a porcelain decorator for the Sèvres factory.

His response to what he saw culminated in a series of excellent Venetian scenes, which included his watercolour of the Doge's Palace, which merely serves as a background for a wonderful collection of moored vessels, ranging from a pair of gondolas to a large three-masted sailing ship, and many fishing vessels with a number of their crews aboard, busily repairing or examining their nets.

Much of his work has a blue-grey effect, and something of this colouring is reflected in this watercolour which is an excellent example of his marine painting.

Examples of his work can be found in the local art galleries of Birkenhead, Lincoln, Scarborough and Whitby.

Paul Marny, *Venice — the Doge's Palace*. 23¾in x 41¼in, Brian Sinfield.

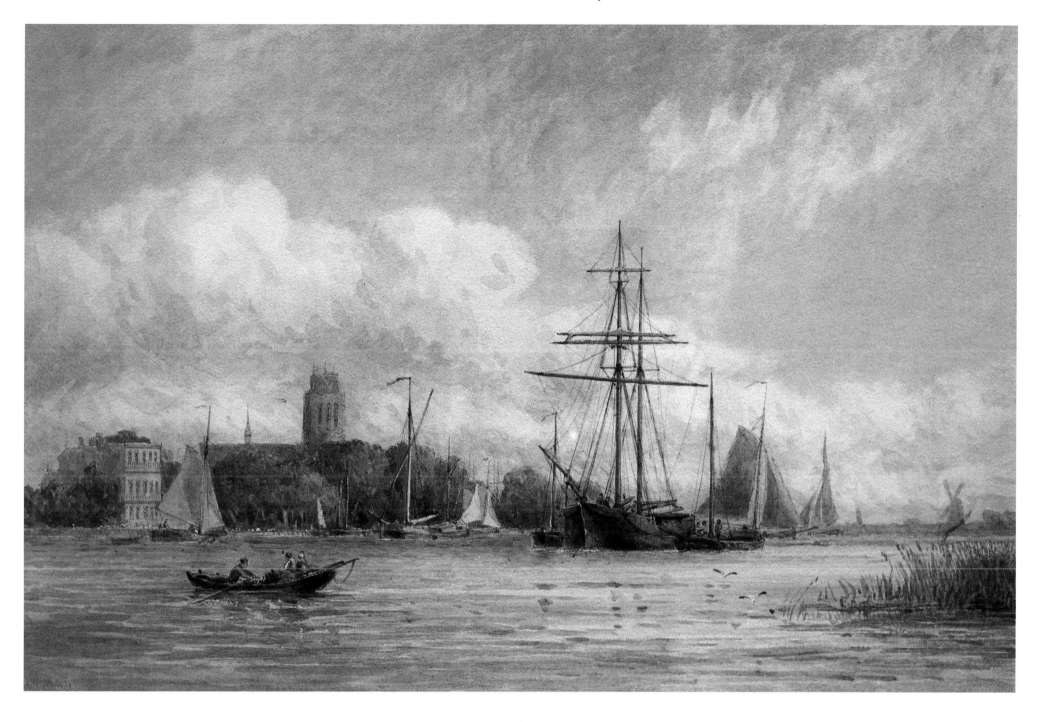

Captain May painted in the tradition of Clarkson Stanfield and E. W. Cooke, but unlike those two artists his best work was done abroad, especially in Holland, which supplied him with the subject matter for a large number of his watercolours. This is a pleasant example of his work in which he gives an impressive display of his command of perspective, where the eye is carried irresistibly towards the rowing boat in the right foreground, and onwards to a distant windmill lying far beyond the anchored sailing barges. A distinctive feature of this watercolour is the large patches of sunlight which have been used to illuminate the painting and throw up in relief all the various craft.

Walter William May, *Sailing Barges and Other Craft off Dordrecht.* 9¾in x 15in, Appleby's.

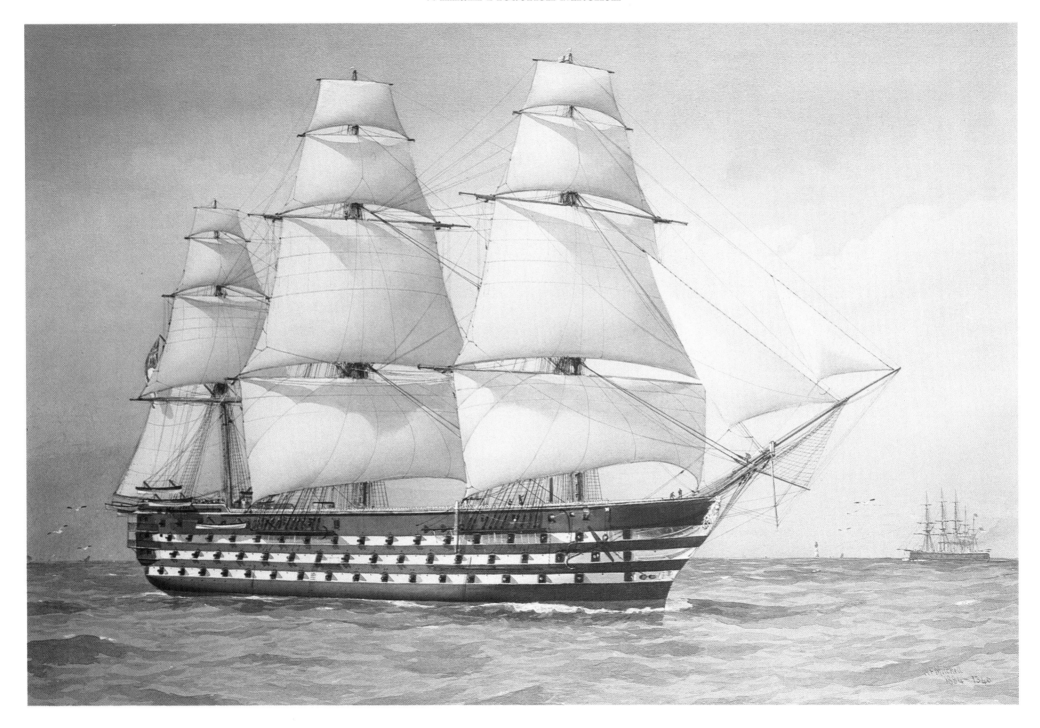

Until recently the name of W. F. Mitchell was hardly known, and even today he remains an underrated artist, except within that small circle of people who are highly knowledgeable about ship portrait painting. His watercolour here shows the clarity of his art work and his superb draughtsmanship.

In pictures of this nature it was a matter of pride for a ship portrait to have every detail right, with everything exactly in its scaled proportions. The end result may not have been a photographic facsimile of the ship, but it was near enough to the original to count almost as such.

William Frederick Mitchell, *The Three-Deck Battleship Victoria*, 1884. 20in x 28in, David James.

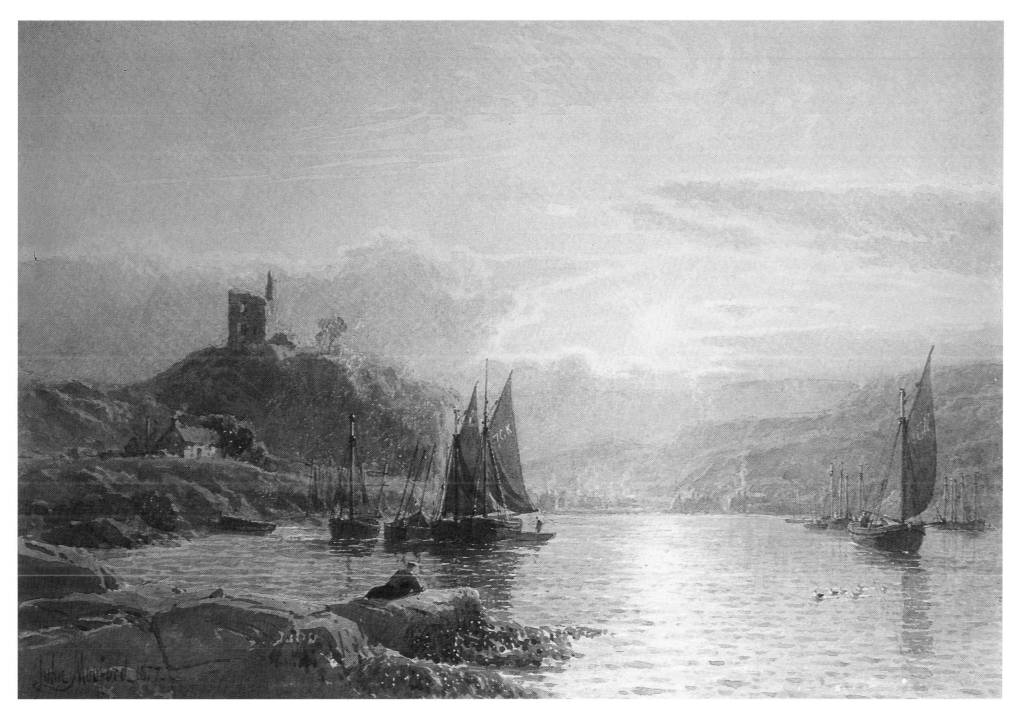

In his own lifetime Mogford was a successful marine artist whose reputation remained secure for a long period from 1846 to 1885. With thirty-three of his pictures shown at the Royal Academy, and with nearly four hundred paintings in all to his credit, to say nothing of having a following of his work in Australia, one would have thought that his reputation would have lasted long after he had gone on his way. Yet for some inexplicable reason it has waned enough for his name to be omitted from at least two books on marine paintings published in recent years. Happily, his work is still liked and admired in those circles which count for the continuing circulation of his work in the art market — those of the dealers and the public.

The untitled watercolour shown here was almost certainly painted in Scotland, which he visited several times on the painting expeditions that also took him to Wales and Cornwall. It is one of those watercolours that contains a number of different ingredients to entertain the eye, including a large number of fishing boats, a country cottage, distant houses, a fisherman reclining on a rock, and a ruined castle which overlooks the whole scene.

John Mogford, untitled watercolour, 1877. 9½in x 13¾in, David James.

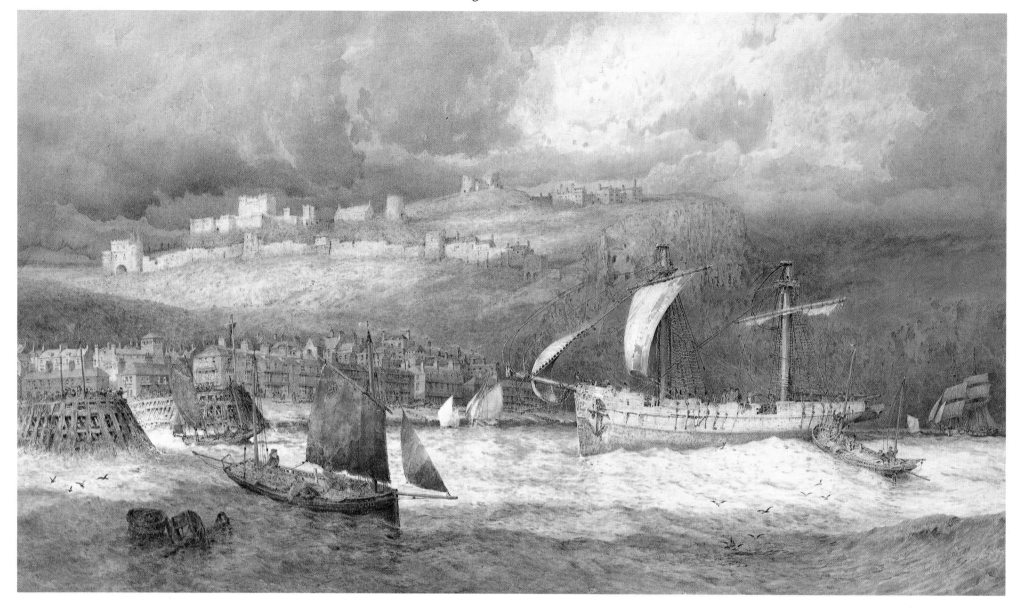

George Nattress, untitled watercolour. 16⅜in x 28¾in, Appleby's.

Many of the nineteenth-century artists who were either land-scape or topographical artists tried turning their hand to the occasional marine watercolour. Often their efforts were surprisingly successful, considering they were painting for what had always been a highly specialised field, calling for particular skills and knowledge.

Among these must be included this watercolour by George Nattress who was primarily a topographical artist. With this picture he was careful not to involve himself in trying to paint any ship with a complicated rigging, and the final result is an unusual marine painting in which the ruins of Dover Castle and the groups of houses are almost as important as the sailing vessels plying to and fro around the harbour.

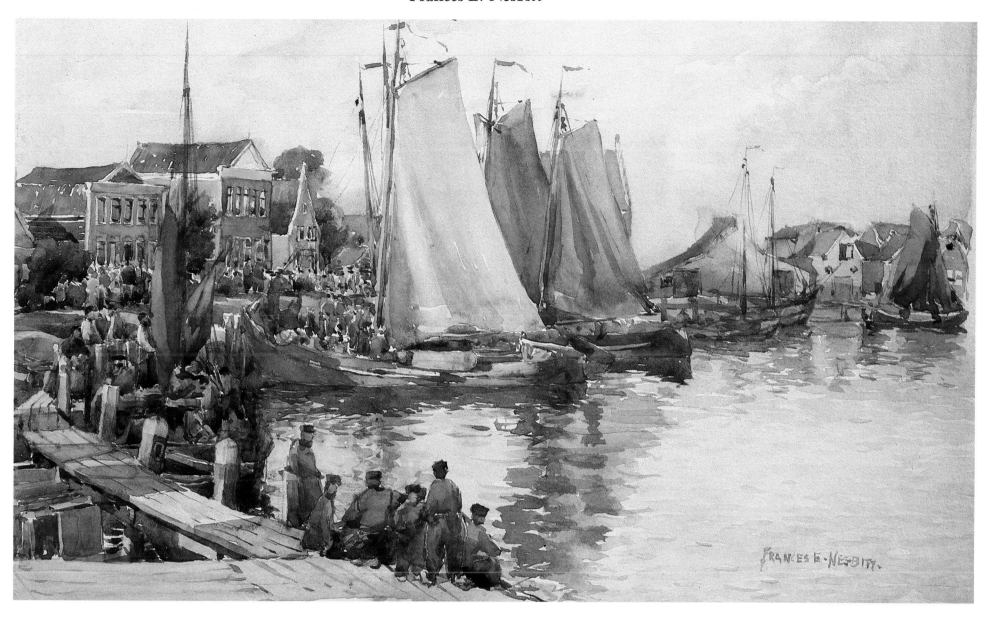

Frances E. Nesbitt, *The Quay at Vollendam*. 8¾in x 13½in, Bourne Gallery.

Marine painting was always essentially a male pursuit for a number of obvious reasons, most of them concerning the social climate of the nineteenth century. The idea of a woman mixing with rough fishermen or venturing out alone and setting up her easel on some foreign quay would have horrified most people in those days.

Frances Nesbitt was one of the few who did. An independently minded spinster, she painted quite a number of marine subjects, both at home and abroad, including this one of the quay of the quaint little Dutch fishing village of Vollendam, which came into being in the fourteenth century. Like many other artists she was attracted to it by the picturesque costume of the villagers and their fishing smacks. Mostly done in varying shades of brown wash, it gives us a lively view of a busy fishing village which has hardly changed to this day.

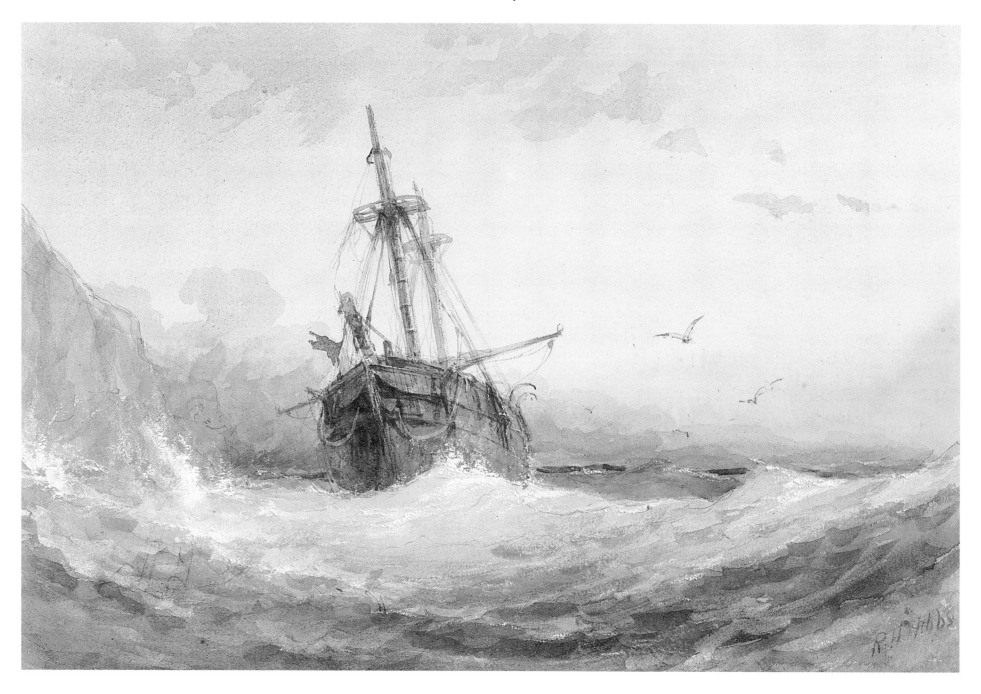

Richard Henry Nibbs, *The Hulk*. 23in x 37in.

Nibbs was a prolific and once very popular marine artist of considerable ability, with a slightly coarse technique which suited his scenes of storms and battles at sea, two subjects in which he tended to specialise. This watercolour is typical of the sort of painting he did very well, a simply executed watercolour done almost entirely in a sepia wash of an abandoned ship whose decks have been swept clean by a storm, leaving it to pursue its lonely course, with only the gulls for company until it meets its end at the bottom of the ocean.

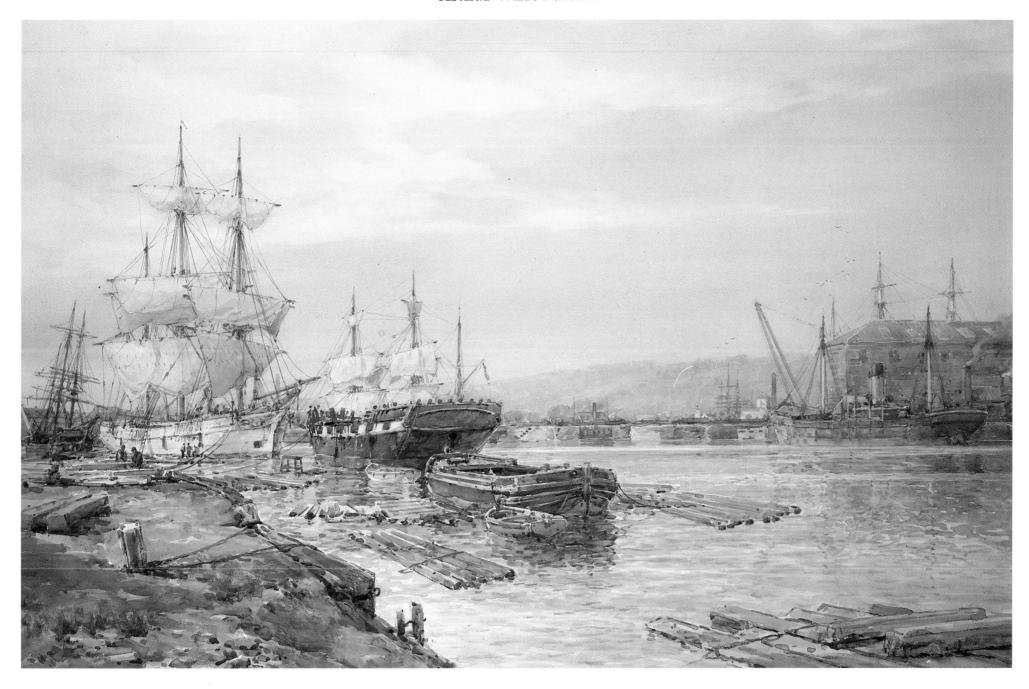

This Bristol marine artist was well known for his strong, assured style. He flourished between 1867 and 1904, though he still continued to paint until later in the twentieth century, when his style changed dramatically after he had made the second of his two visits to Venice. Where before he had always painted in subdued colours and in a loose style, his work assumed almost overnight a Pre-Raphaelite clarity of colour and detail.

Like so many of the nineteenth-century artists he was over-fond of giving his pictures long-winded titles, such as *After*

Tempest when the Long Wave Broke Down the Thundering Shores of Bude and Bos, which does not detract from the quality of his work but does show him to be a Victorian at heart, though he did not die until 1931.

This watercolour is very typical of his work before he changed his style. The 'Float' which he shows here was first used in 1840, and was a type of dock where a ship could float while minor repairs were carried out. The detail in it is crisp and clear and totally realistic in its approach.

Arthur Wilde Parsons, *The Float — Bristol*, 1911. 19¾in x 39in, Brian Sinfield.

One of the great adventures of Pocock's life must have been in 1794 when he sailed with the Fleet under Lord Howe and took part in the epoch-making battle of the 'Glorious First of June', which he recorded in a series of rapid sketches while aboard the HMS *Pegasus*. It was this habit of making sketches on the spot which started him off on his painting career, when he used to record what he saw during his voyages to and from America while working as a captain under Richard Champion, the Bristol porcelain manufacturer.

Although he took part in other campaigns, many of his paintings were 'reconstructed' from accounts given to him by some of his naval friends. This watercolour was obviously a reconstructed one, as by the time this was painted his travels had become more restricted following his marriage in 1780 to a Bristol girl named Anne Evans, who was to bear him seven sons and two daughters. One of his sons, William Innes Pocock (1783–1836), was to become a marine artist himself after a colourful career at sea.

With his oils, Pocock normally painted large panoramic scenes taken from a bird's eye view of ships going into action in battle order. In his watercolours, however, he mostly confined himself to harbour views, coastal scenes and small naval encounters such as in this watercolour of an affray between a French ship and British sailors and marines on the Caribbean island of St Lucia.

Unlike many of his watercolours, which have faded badly with the passage of time, this one has retained its bright colours in which the rich green of the tropical vegetation and the browns of the sun-baked earth remain almost as fresh as the day they were painted all those years ago.

Other examples of his work may be seen at the Norwich Castle Museum, the Bristol Art Gallery, the Derby Art Gallery and the National Maritime Museum, Greenwich.

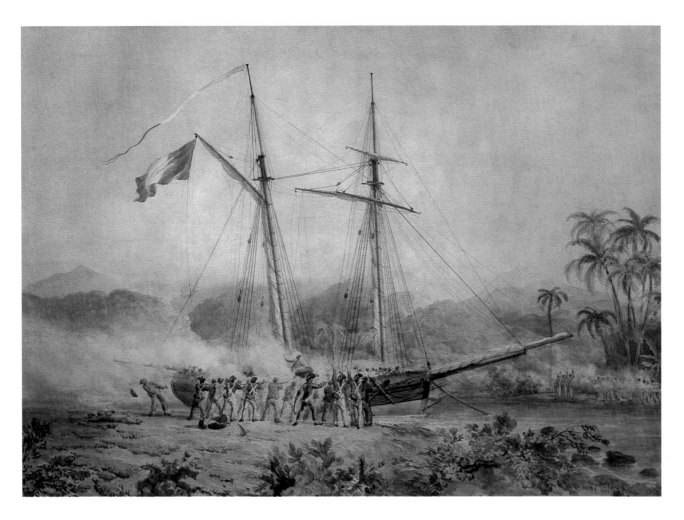

Nicholas Pocock, *A French Brigantine being Cut Out by British Sailors and Marines from Hurricane Hole, Marigot Bay, St Lucia*, 1800.
15½in x 21½in, J. Morton Lee.

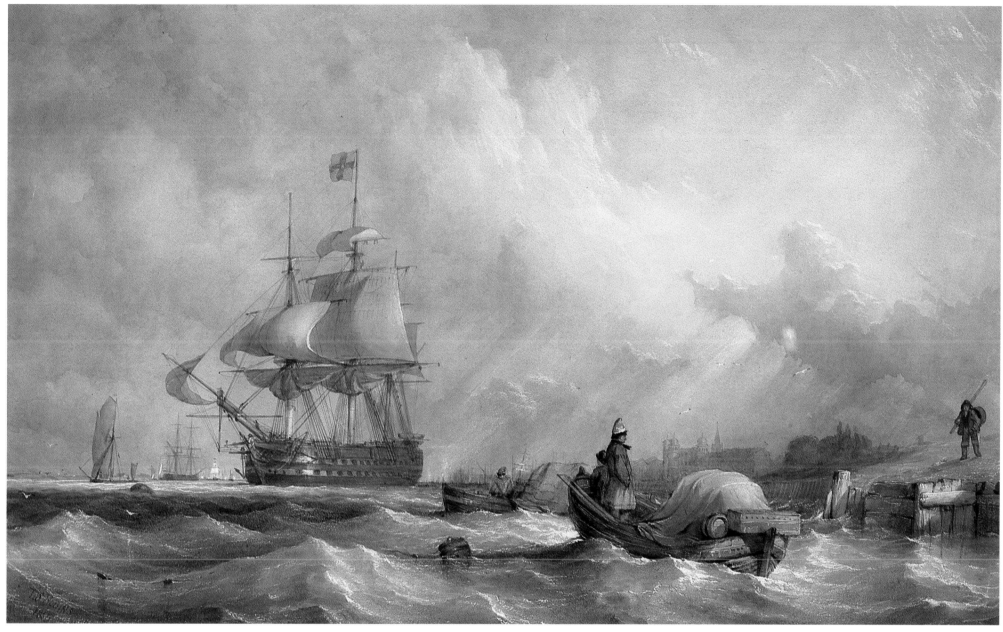

It has always been accepted that Robbins was a highly accomplished artist, but no recognition has ever been made of his technical knowledge of shipping and sailing in general. To a non-sailing person the painting of the two-decker in this watercolour is just another example of one of the old sailing ships, but to an expert it is much more. Here, for instance, are a modern expert's notes on how its sails have been set.

The courses have already been clewed up and now the fore topsail and main top gallant are being clewed up, after the yards have been partially lowered. The jib is also being hauled down. This will leave only the main topsail and mizzen topsail set.

As Robins undoubtedly did this watercolour from a series of sketches which he then worked up in his studio, his knowledge of shipping of this sort must indeed have been formidable.

Apart from the two-decker, the watercolour is full of telling details, from the heavily laden local boat in the foreground to the distant spritsail barge in the left distance beyond the two-decker.

His work may be seen in many of the country's art galleries, including the Birmingham Art Gallery, the Preston Manor Museum at Brighton, the Portsmouth Art Gallery and the National Maritime Museum at Greenwich.

Thomas Sewell Robins, *Two-Decker off Portsmouth*, 1855. 16½in x 23¾in, Royal Exchange Gallery.

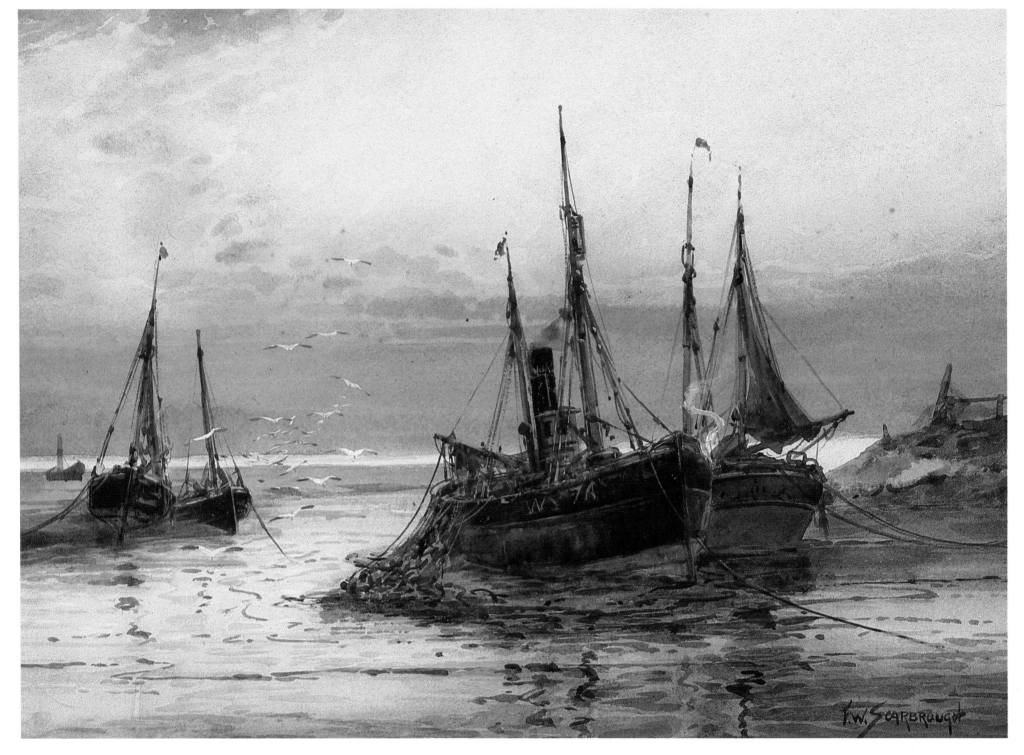

Frank W. Scarborough, *Low Tide at Kings Lynn*. 9in x 13in, Fine-Lines (Fine Art).

Although there are certain similarities in the work of Charles Dixon and Frank Scarborough in that they both liked painting in the Pool of London and using smoky effects to emphasise the activities that went on in those waters, the latter artist occasionally painted atmospheric watercolours quite different to his usual work. This picture, of a fishing fleet moored and anchored for the night with the sun beginning to set over the sea, is very much a 'mood' piece in which a great deal of care has been taken to capture the varying shades of light on the sea, so often seen at the end of a fine day, with hardly a ripple disturbing the inshore waters.

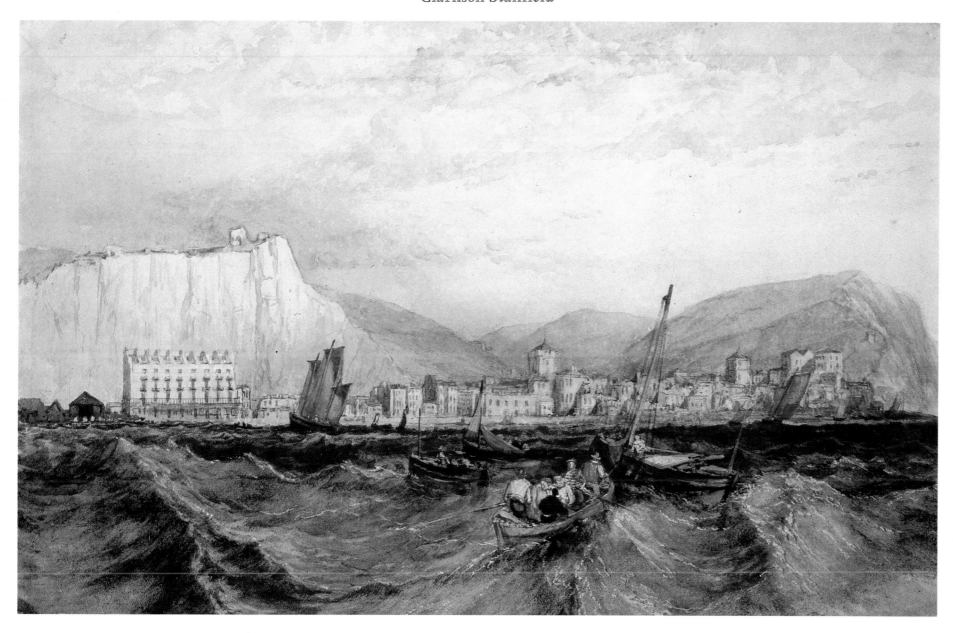

Brightness, clarity and accuracy — these were the qualities for which Clarkson Stanfield was applauded throughout his whole career as an artist. His impact on the art market, however, lay more in the way he could bring a sea scene to life. How important this sort of photographic realism was to the nineteenth-century viewer cannot be underestimated, and has never been fully appreciated by people today who are used to seeing things as they actually occurred through the medium of photography or the cinema. Victorian realism in painting is now, more often than not, contemptuously dismissed as being the product of unimaginative minds.

Ruskin was a great admirer of this aspect of Stanfield's work, but, as usual, when he gave praise it was too fulsome to be taken seriously, as with his comment on Stanfield's painting of a wave. 'His surface is at once lustrous, transparent and accurate to a hair's breadth in every curve.'

This sort of criticism may have meant something in Stanfield's times, but it is fairly meaningless to anyone today. Stanfield's work *was* often marvellous, but to find the secret of his art we must look beyond his ability to capture a scene. It lay in his skill in combining realism with broad atmospheric effects that had a unique poetic quality to them, which lifted most of his paintings far above the work of the average marine painter. This gave his watercolours a quality which made them difficult to copy, unlike his oils, where fakes were always turning up.

Unlike many of the famous artists of his time, little is known of Stanfield's methods of working as he published nothing that might give some clue.

This watercolour, *Hastings from the Sea*, is an interesting one because it comes from a book entitled *Stanfield's Coast Scenery* in which forty of his paintings were used and engraved in line, and included scenes painted at Dover, Falmouth, Rye, Portsmouth and Plymouth.

Examples of Stanfield's work may be found at the National Maritime Museum and the Tate Gallery, and in many of the provincial collections.

Clarkson Stanfield, *Hastings from the Sea*. 7in x 10⅞in, Spink.

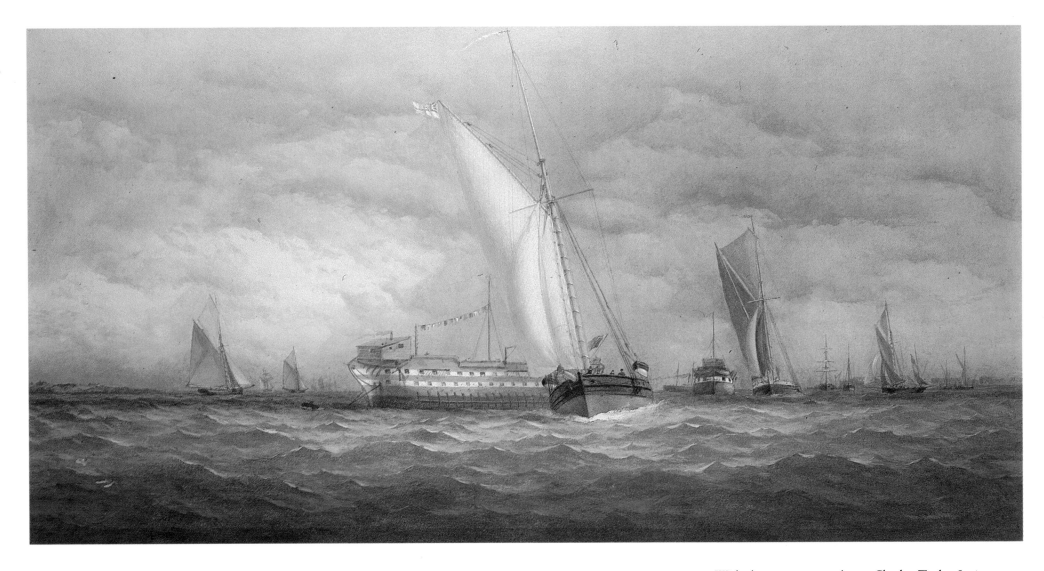

(a) Charles Taylor Junior, *On the Medway*. 15¼in x 29¼in, David James.

With these two watercolours, Charles Taylor Junior covers two separate stages in the history of English shipping. In picture (a) all the vessels to be seen, with the exception of one in the far distance, are wooden sailing vessels. Beautiful as they all look skimming across the water, their days were numbered. The lack of speed had always been against them but their real enemy was dry rot. It was this inevitable process of decay which gave the ships of the Royal Navy a life expectancy of no more than fifteen to twenty years. The East India Company was even more pessimistic. Its ships were considered to be of no further use after eight years.

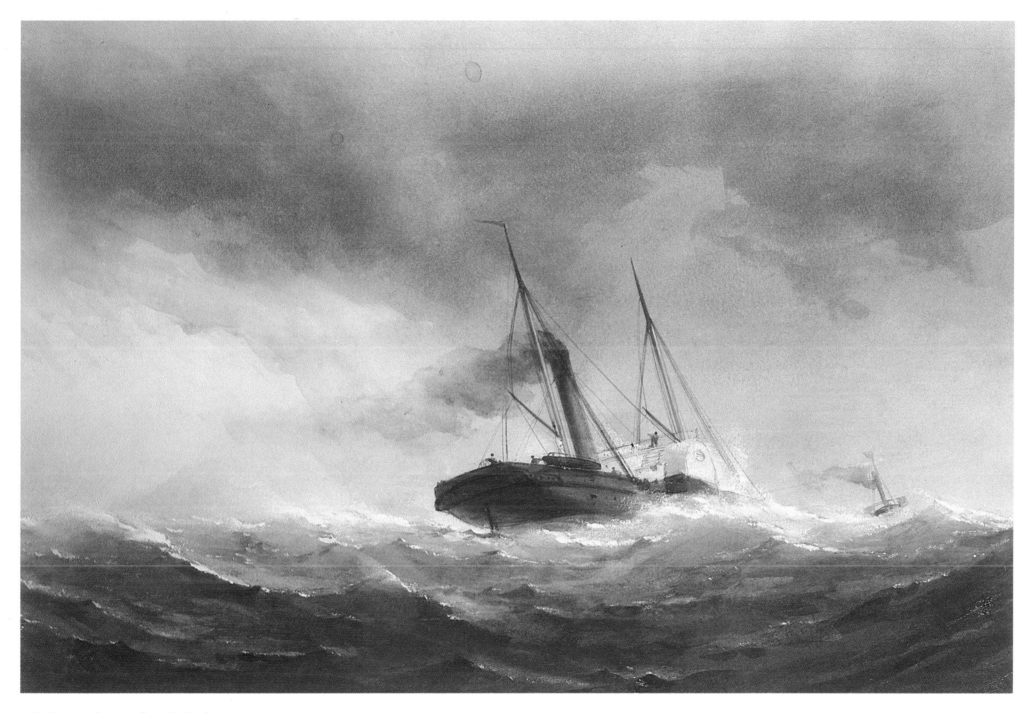

In the second watercolour (b) Taylor takes the evolution of
English shipping a stage further to the age of steam propulsion
with this picture of a paddle steamer. These were often used as
short-haul passenger ships doing a regular run, and were called
packets because they carried mail.

Examples of Taylor's work may be seen in the National
Maritime Museum at Greenwich.

(b) Charles Taylor Junior, untitled watercolour. 13½in x 20in, David James.

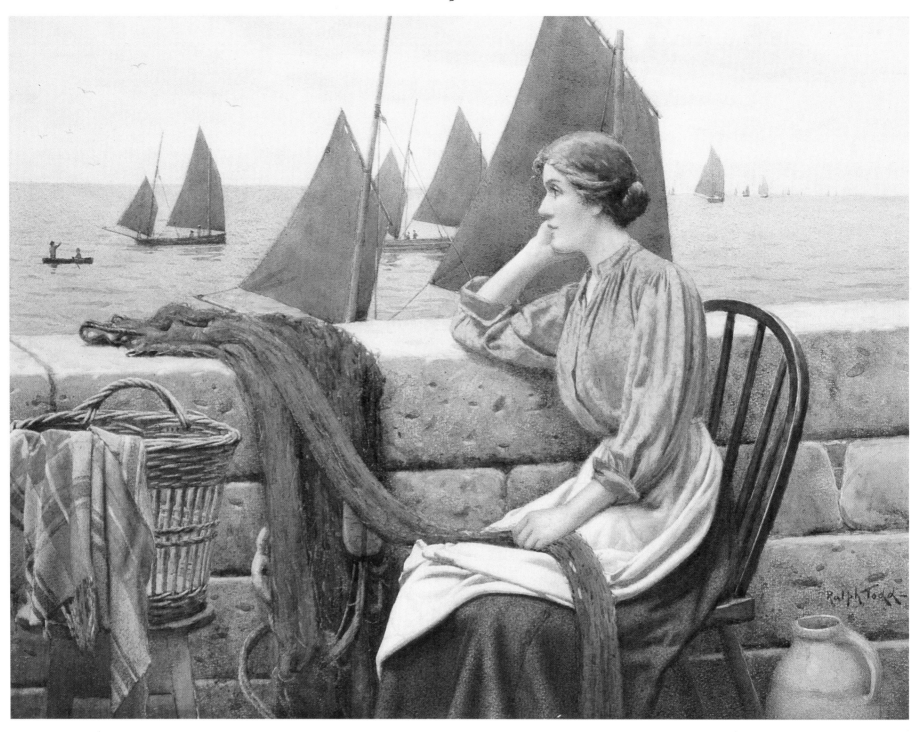

Todd seems to have had rather an eye for the ladies, which may have prompted him to paint so many of the Newlyn fisherwomen framed against an appropriate background of fishing vessels, such as this attractive study. Not all his watercolours were as good as this, as some of them were coarsely painted and unattractive to look at.

He was a close friend of Stanhope Forbes, who found him convivial company, but his loyalties to the Newlyn School were never very deep. Three years after his arrival in Newlyn he was planning to give up painting and find himself a rich widow. According to Forbes, anyone would have done as long as they had money. Todd never found his rich widow, but he did marry soon afterwards.

Ralph Todd, untitled watercolour. 11½in x 15½in, Fine-Lines (Fine Art).

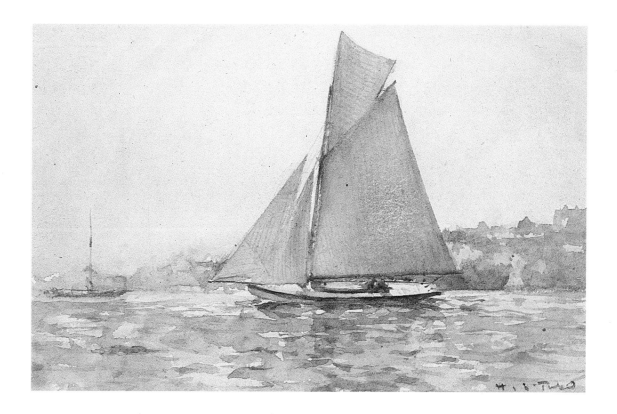

'They are flocking in here every day,' Stanhope Forbes wrote enthusiastically about the artists who were beginning to arrive in the Cornish fishing village of Newlyn, and were to help him form the now famous Newlyn School of Painters (see page 17). One of the most talented of these new arrivals was Henry Scott Tuke, though he never really identified himself with the school, seeing himself rather as a distinct branch of this close-knit community.

It is certainly true that he never tried to paint pictures in which a dramatic image was coupled with a subject of immense popular appeal, often involving the wives of fishermen in some highly emotional tableau, as did many of the artists of the Newlyn School. Tuke's path ahead lay in the direction of Impressionism, though he had always been a *plein air* artist. Like the genre artist Norman Garstin, who had lived in Penzance for many years, Tuke had long since come to realise that 'beauty lies as much in light, the atmosphere that surrounds all things, as in their actual form and fashion'.

His watercolour here has that wonderful essence of simplicity to it which often conceals great art. This particular picture is not great art, but it is the work of a first-rate watercolourist who knows exactly what he is about, especially in his handling of the water which is purely Impressionistic and not unlike a subdued Monet.

There seems to be a remarkable absence of Tuke's marine paintings in the public galleries, though his genre paintings and portraits are to be found in some of them. However, a number of his maritime paintings can be seen at the National Maritime Museum at Greenwich. Falmouth Art Gallery contains a showcase devoted to his life and work.

Henry Scott Tuke, *A Gaff-Rigged Cutter Under Sail.* 3¾in x 6in, Royal Exchange Art Gallery.

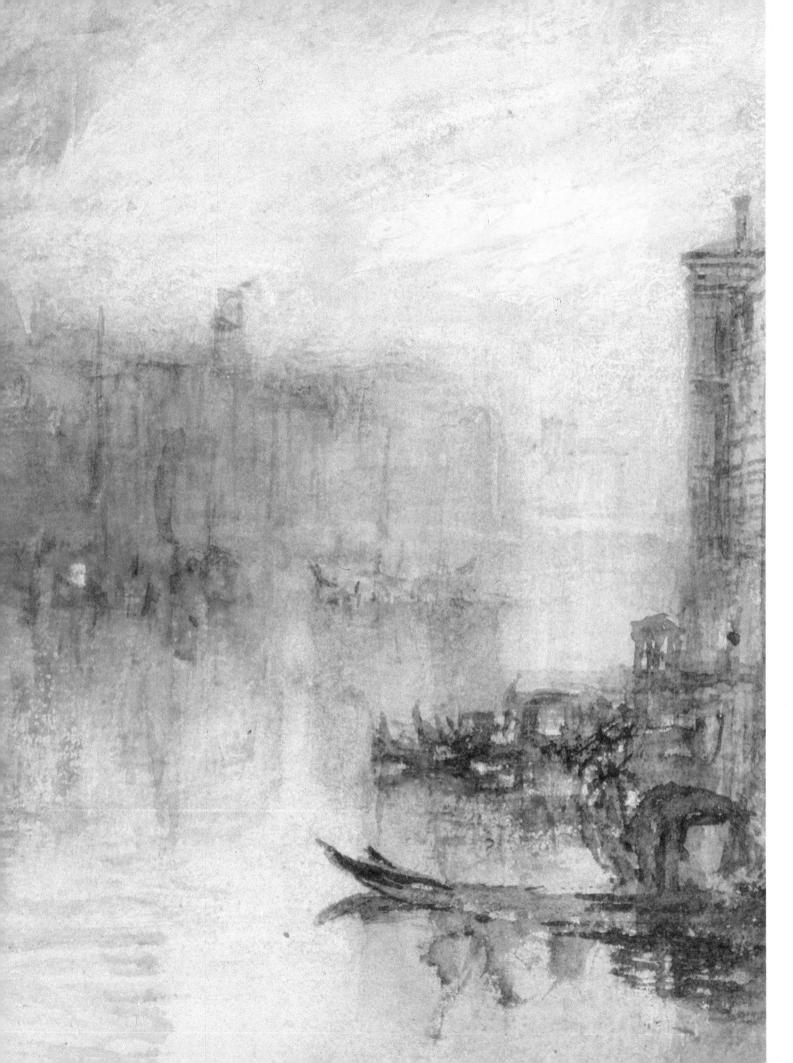

This watercolour caused a sensation when it came up for auction in 1988, when Phillips the auctioneers sold it for £400,000, the highest price a watercolour has ever fetched under the hammer. It belongs to a set of watercolours that Turner painted during his last visit to Venice in 1840, the most highly prized of these now being a small group of storm scenes. The picture shown belongs to that group and was owned by Griffith, Turner's agent and close friend, who had been a substantial collector of Turner's work since 1829 and had retained some twenty-five of his Venetian scenes. Five of these are now in private hands, the remainder in museums.

This painting was the last to have remained in the possession of the Griffith family. It was on loan to the British Museum from 1972 until it was consigned to Phillips for sale. Executed in watercolour with body colour and scrapings out over traces of pencil, it shows dark storm clouds gathering over boating on the Grand Canal and contrasting starkly with a typical Turner golden sky.

It was soon after completing these Venetian paintings that Turner's powers began to fail. 1845 marked the onset of his period of decay. (See pages 12 and 13.)

If Turner had died young his reputation would have been different from what it is today, as it was only after 1820 that colour became a major factor in his work. Working steadily towards being able to paint the sun in all its strength and glory, he strove constantly to paint the unpaintable, and almost succeeded. In this alone Turner remains pre-eminent as a watercolour artist.

A large number of Turner's paintings can be seen in the Clore Gallery, an annexe to the Tate Gallery which was opened in April 1987.

As with most marine artists, Turner was fascinated by the elements. In his case, his interest was a subjective one in that he was far more interested in interpreting their existence in a way that had never been achieved before, rather than capturing them in a flat photographic fashion. His treatment in this watercolour of the dark rain clouds, blue skies and patches of golden sun reflecting their different colours on the waters is essentially a romantic one, where everything, including the gondolas and small craft, is subordinate to these elements.

It seems strange that this poet of the palette should have been seen by so many of his contemporaries as boorish, unintelligent and vulgar. Turner's great tragedy was that both as a man and an artist he was often beyond understanding.

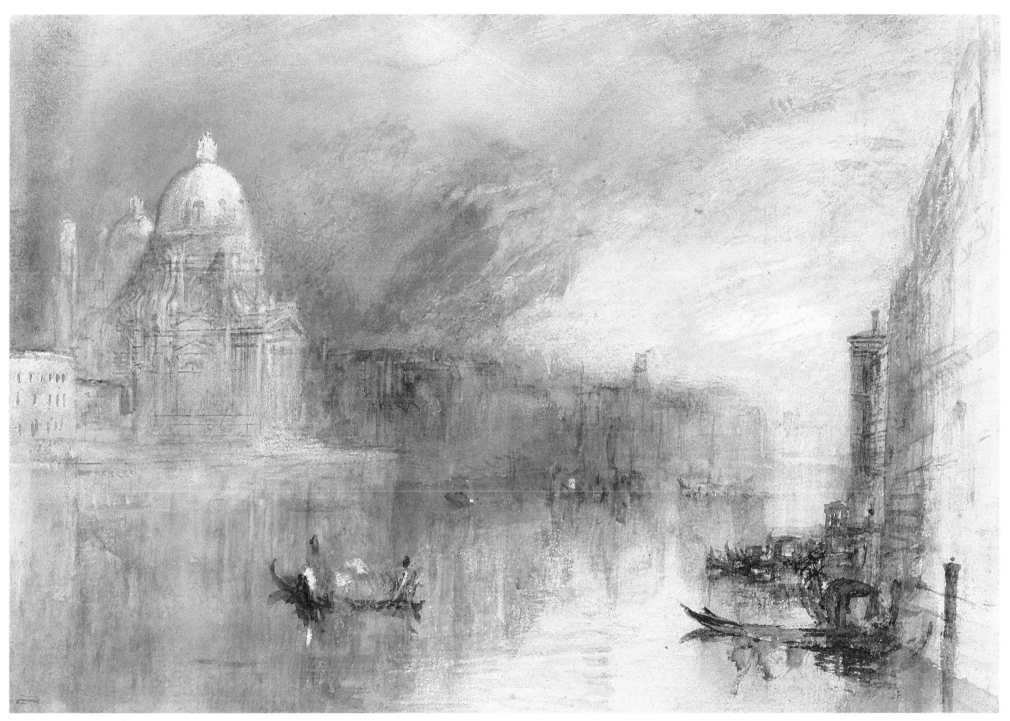

Joseph Mallord William Turner, *The Grand Canal with the Church of Santa Maria della Salute.* 8½in x 12½in, Phillips.

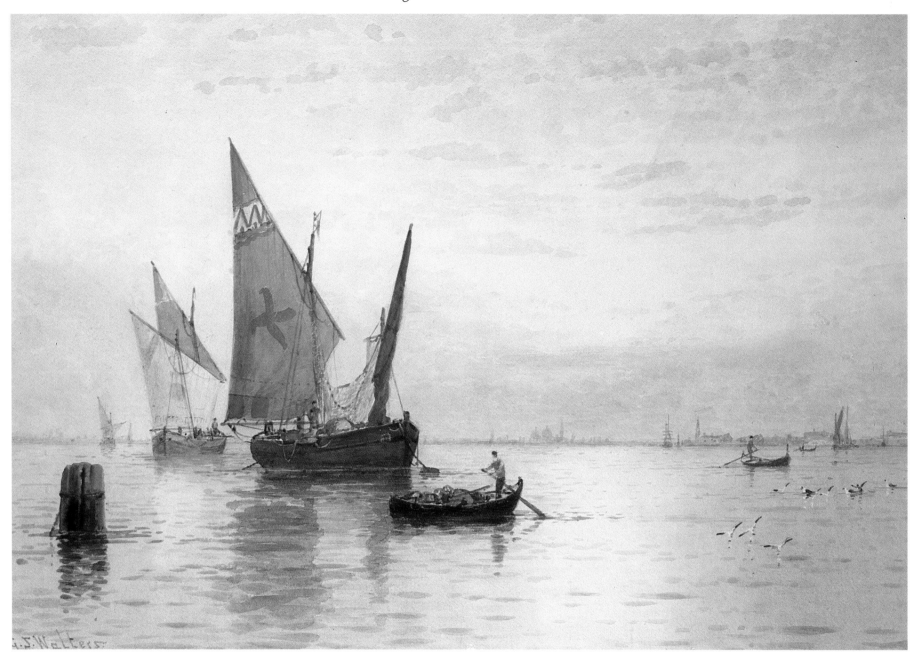

Venice was a painter's paradise, attracting all manner of artists to bathe in its translucent light and sample its hedonistic and cultural delights. George Stanfield Walters was one of the many who visited Venice and, like most of them, spent much of his time painting on the Lagoon or the Grand Canal which winds through the town in the shape of the letter S.

Every artist's response to Venice varied, according to his temperament and his talent. Walters's response to it was a romantic one in which he uses two characteristics of his work in this watercolour — the employment of a very faint pink to add a warm glow to his painting, and using the light at sunset when the fading of the day casts darkening shadows on the water. It is a romanticised picture of Venice, true enough to where he was painting, but giving no clue that another Venice might exist in the innumerable dark and refuse-littered canals that serve as arteries to the Grand Canal. But then realism of this nature very seldom played a part in the scheme of an artist's intentions when visiting Venice.

Stanfield Walters was trained as an artist by his father, Samuel Walters, who was a competent but rather uninspired marine painter. His son was by far the most prolific artist, who, besides exhibiting regularly at the Royal Academy, also exhibited 340 pictures at the Suffolk Street Galleries. Oddly, considering his track record, he was an unsuccessful candidate for the NWS no less than six times.

Examples of his work may be seen at the National Maritime Museum, Greenwich, the Victoria and Albert Museum, and at the Bootle Art Gallery.

George Stanfield Walters, *Fishing Boats on the Lagoon, Venice.* 9½in x 13¼in, David James.

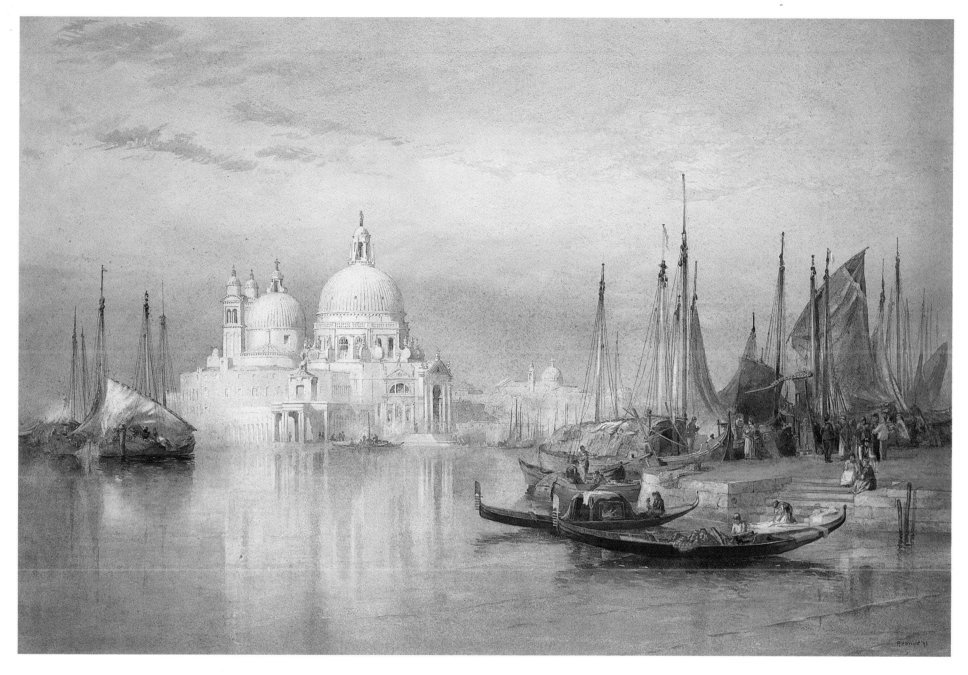

As he was an architectural artist, Wright probably went to Venice to paint its ancient buildings, and was so taken by the scenes of boating life around him that he was prompted to paint this watercolour of the entrance to the Grand Canal, which had the added attraction for him of having as its backcloth the architectural glory of the church of Santa Maria della Salute, built in the seventeenth century.

Wright's watercolour is totally different in colouring and subject matter from Stanfield Walters's painting opposite, in which the artist attempted to give us a painting on the lines described in the accompanying text. Wright, on the other hand, seems to have modelled his painting after the style of the old Venetian masters in such a way as to give the impression of a much earlier Venice than that of 1893, when he painted it.

His collection of boats moored to the busy quayside features a number of vessels appearing in nineteenth-century Venetian scenes: fishing boats share space with a houseboat, small trading craft and gondolas, a feature of Venetian life since at least 1094.

Richard Henry Wright, *La Salute — Venice*, 1893. 15½in x 23in, Brian Sinfield.

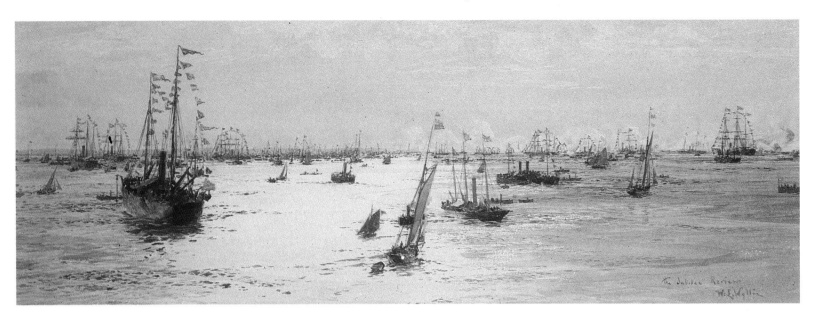

(a) William Lionel Wyllie, *The Jubilee Review*. 6in x 16in, David James.

(b) William Lionel Wyllie, *The Passing of a Great Queen*. 8½in x 13¼in, Royal Exchange Gallery.

These two watercolours by Wyllie make an appropriate coda to this book as they are a record of the two significant occasions in British history in which the Royal Navy played an important part in the country's last two great displays of pomp and ceremony before the sun set for the last time on the Empire.

In September 1896 Queen Victoria's reign had surpassed in length that of any other English sovereign, but at her request the intended public celebrations were deferred until the following June, which would mark her sixty years as Queen of England. The great Diamond Jubilee that took place on that great historic occasion saw a whole series of national celebrations, including that of bringing troops from all her colonies and dependencies to take part in a great Jubilee procession through the streets of London.

The occasion was a momentous one, but of far greater significance here was the review of the Fleet by the Prince of Wales at Spithead. It was the largest assembly of ships ever gathered at one anchorage, and made an awe-inspiring display of Britain's might at sea. Wyllie was there to record the occasion and clearly painted this view (a) from one of the small vessels on the perimeter of the actual review, which was lined up in the distance in four orderly rows, extending to some thirty miles in all. As such, it is something of a social document as well as being a good example of Wyllie's work.

Four years later the Queen was dead. When her body was transported under escort in the *Alberta* from Osborne, Isle of Wight, to Portsmouth, Wyllie was there again to record another historic occasion, this time from the flagship *Majestic* (b).

Both these watercolours are very representative of Wyllie's work at this time. Never less than a lively and versatile artist, his work suddenly fell out of fashion after World War II, and his reputation was not re-established until 1972, when a major exhibition of his paintings was held in London. Examples of his work may be seen at the Tate and at the Bristol and Liverpool art galleries.

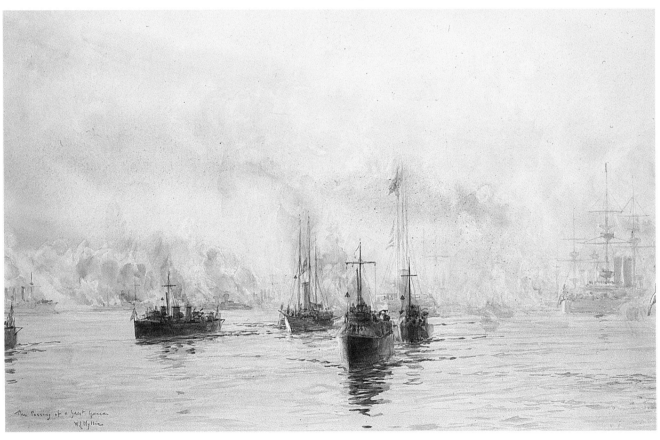

BIBLIOGRAPHY

The books listed here are either still in print or available from a Public Library on order, or to be seen in their reference room. Others, such as A. L. Baldry's *British Marine Painting*, published in 1919, which is long on florid writing but short on hard facts, have been omitted because they are now out of date, or contain nothing that is not available in the listed books. All these have been consulted, along with many other books, and found to be the best available on the subject of maritime art and watercolour painting in general.

Archibald, E. H. H., *Dictionary of Sea Painters*, Antique Collectors' Club, 1980.

Brook-Hart, Denys, *British Nineteenth-century Marine Painting*, Antique Collectors' Club, 1974.

Brook-Hart, Denys, *Twentieth-century Marine Painting*, Antique Collectors' Club, 1981 (contains much useful information on marine artists who spanned the nineteenth and twentieth centuries).

Cordingly, David, *Marine Painting in England, 1700–1900*, Studio Vista, 1974.

Gaunt, William, *Marine Painting, an Historical Survey*, Secker & Warburg, 1975.

Graves, Algernon, *A Dictionary of Artists*, Kingsmead Reprints, 1973.

Halsby, Julian, *Scottish Watercolours 1740–1940*, B. T. Batsford, 1986.

Hardie, Martin, *Watercolour Painting in Britain Volume III. The Victorian Period*, B. T. Batsford, 1969.

Mallalieu, H. L., *The Dictionary of British Watercolour Artists up to 1920*, Antique Collectors' Club, 1976.

Spender, Michael, *The Glory of Watercolour*, David & Charles, 1987.

Wood, Christopher, *The Dictionary of Victorian Painters*, The Antique Collectors' Club, 1971.

INDEX
of Marine Artists